RYE
THROUGH TIME
Alan Dickinson

with Heidi Foster *&* Oliver Dickinson

AMBERLEY PUBLISHING

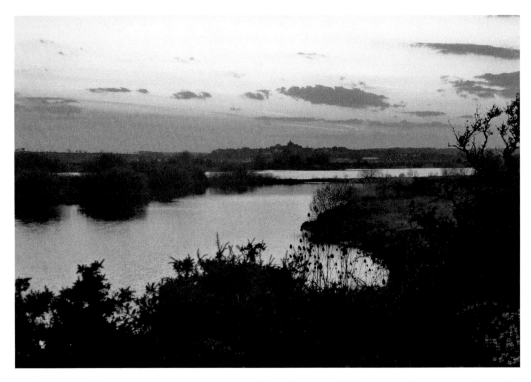

The famous silhouette of Rye seen at sunset from the gravel lake at Northpoint Beach on the Camber Road.

First published 2011

Amberley Publishing
The Hill, Stroud
Gloucestershire GL5 4EP

www.amberleybooks.com

Copyright © Alan Dickinson 2011

The right of Alan Dickinson to be identified as the Author of this work has been asserted in accordance with the Copyrights, Designs and Patents Act 1988.

ISBN 978-1-84868-473-7

British Library Cataloguing in Publication Data.
A catalogue record for this book is available from the British Library.

Typeset in 9.5pt on 12pt Celeste.
Typesetting by Amberley Publishing.
Printed in the UK.

Contents

Introduction

Following the publication of two books of old photographs of Rye and district by Alan Dickinson, there was an invitation to prepare a third, combining old and new images. This presented both a challenge – the location of fresh material – and an opportunity to look at life in Rye and issues of continuity and change.

There is of course a wealth of photographic material from this well-known tourist town on its unique hilltop; it has been popular with visitors for more than a hundred years. The first chapter looks at distant views of Rye in its setting.

Since the author's previous book, there has been a detailed study of the historic town from its origins as a port in the mid-eleventh century through to the seventeenth century. There has also been a parallel study of Rye's buildings, which includes the medieval religious and defensive structures, surviving houses from the fourteenth century, the rebuilding and infilling work of the prosperous sixteenth century, and the decline in quality that accompanied the silting of the harbour in the seventeenth century.

These buildings, as modified in the Georgian and Victorian periods, provide the inspiration for two further chapters and an opportunity to look at life in the historic town from the early days of photography in the 1850s to the present day, including civic life and commerce, transport and social conditions.

The High Street and other commercial streets provide the material for two further chapters. The myriad shops and services of the Victorian and Edwardian photographs are now designed for tourists.

The largest section of the book is that related to Rye's role as a port. We take a clockwise tour around the town's three tidal rivers. We explore past and continuing fishing, shipbuilding, and quay activities, charting the change from heavy cargo traffic to leisure.

Finally, the selection looks briefly at the road approaches into the town and the three nearest adjoining villages, each representing a different landscape and economy.

What of our themes of continuity and change? The former has been remarkable. The town has escaped wholesale new development and remains surrounded by fields and open spaces. How has this happened? Variously it is due to the town's economic decline; its geographical location surrounded by rivers, which limited development and encouraged industry to remain close to the town; corporation ownership of land around the town; and the advent of planning controls after the last war, which has protected the town's buildings.

While the buildings have not altered much in 150 years, change is of course apparent in costume, vehicles and street signs. Nearly all of the industries around the town have been abandoned or moved away, and leisure and tourism have taken their place.

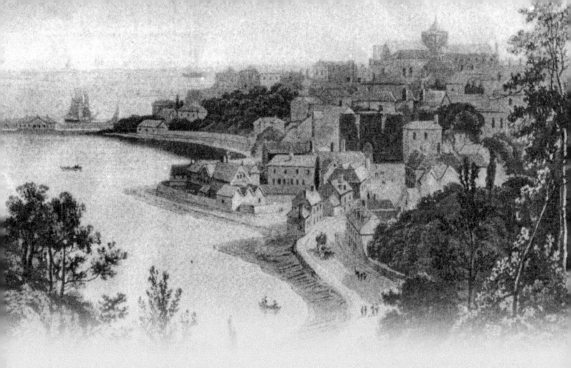

CHAPTER 1

The Setting of Rye

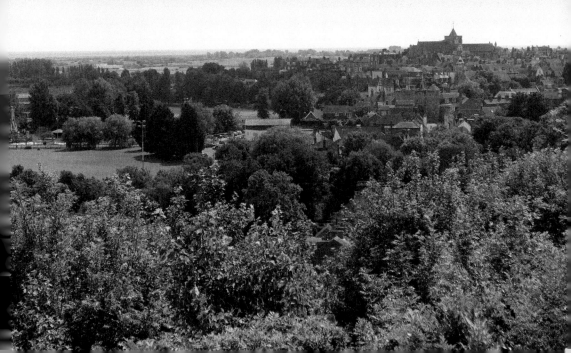

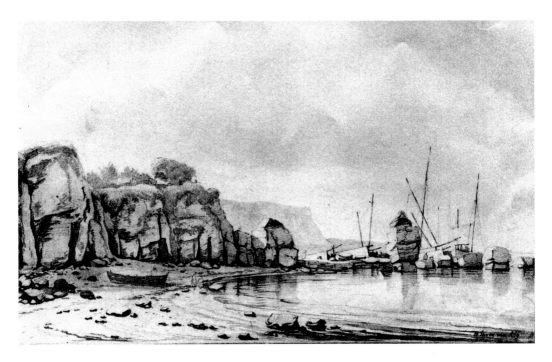

An Island Town

The previous page shows William Daniell's drawing of Rye from Point Hill in 1823, ten years before the Rye Embankment Act resulted in the loss of the tidal beach. The drawing on this page, by the Dutch artist Esselens, dates from the 1660s. It shows the opposite side of the rocky promontory (centre left in the 1823 drawing), with boats behind and Point Hill in the background.

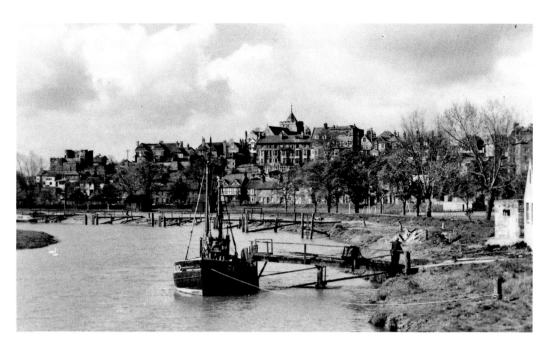

Rye from the East

This iconic view of the town is from the tidal River Rother, with the fishing quay in the foreground. It is not quite as picturesque now as in the inter-war view, following construction of the piled quay and buildings in 2006. The squat pyramid of the church spire crowns and echoes the pyramid shape of the town.

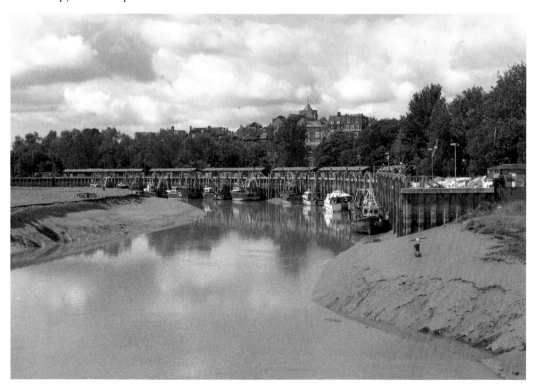

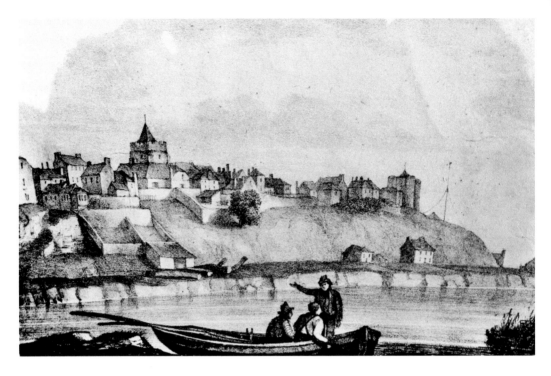

Rye from the South

This early nineteenth-century view shows the steep and rocky southern slope of the town beyond the combined tidal rivers Tillingham and Brede, which then followed a course closer to the town. Reclaimed land around the town became allotments, forming an attractive setting next to the Edwardian terraced housing and the A259 trunk road at South Undercliff.

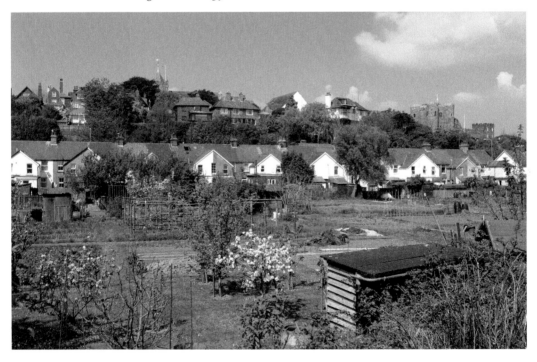

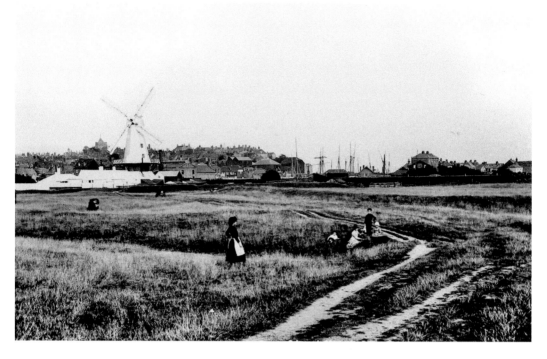

Rye from the West

This reclaimed marsh is now a car park. The shape of the town was much clearer in the 1900s and the ships' masts at the busy Strand Quay were visible. The current view shows the masking effect of tree cover. The windmill was rebuilt as a shell without machinery after a fire in 1930.

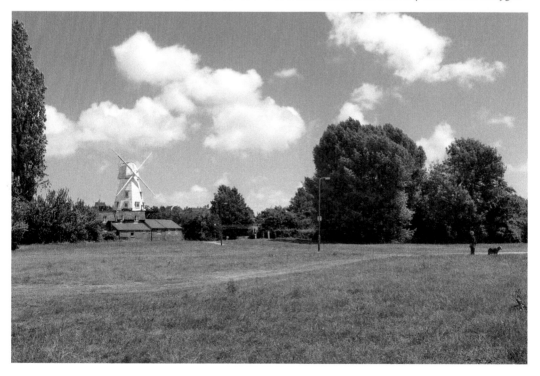

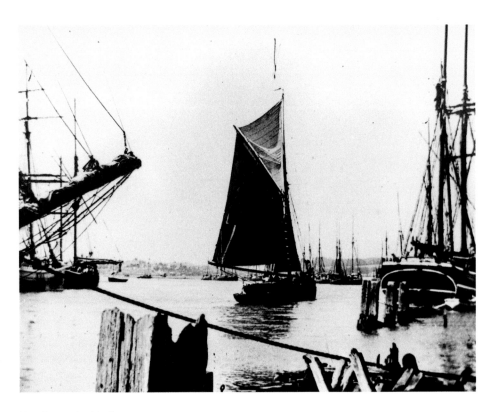

Rye from the Harbour

There is much that is similar in these two views of the town from Rye Harbour at high tide. In both pictures, the east bank is lined by moored boats. There is a sailing vessel in the channel and the silhouette of the town is unchanged. The contrast lies in the change from cargo vessels to leisure craft.

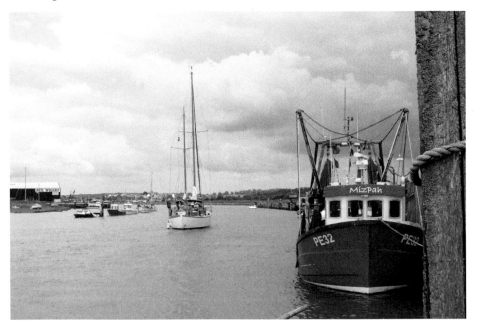

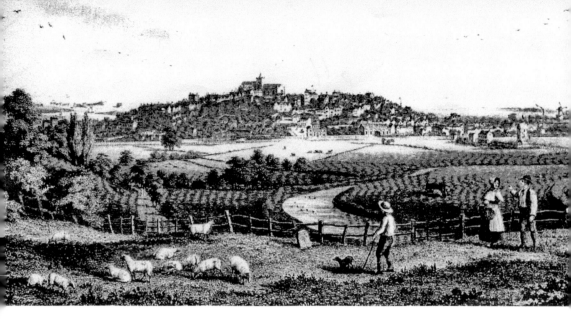

Rural Surroundings

These views from the high ground at Leasam, which lies to the north-west, show the town against a pastoral background with the sea a distant blue strip in the modern photograph. In 1851, as now, Rye was closely adjoined by sheep pasture and the River Tillingham wound its way around the town.

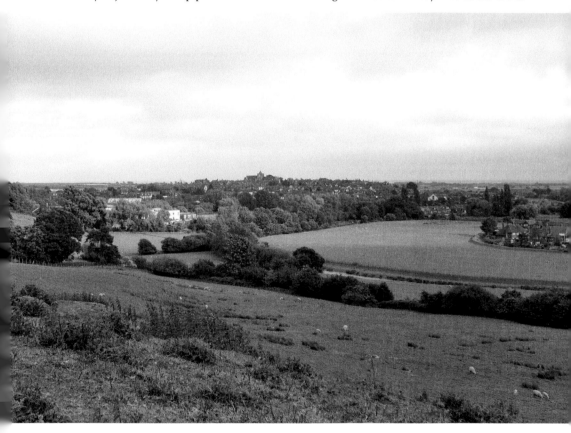

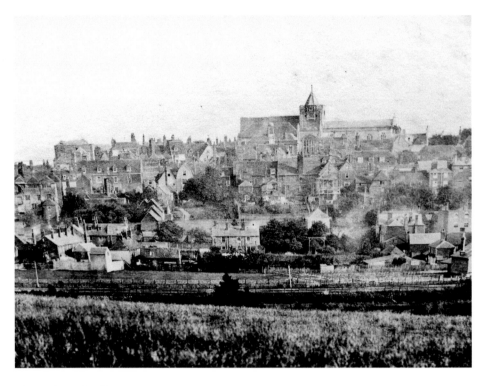

The Red Roofs of Rye

The earlier view was taken in 1859, one of a series from the high ground to the north. Most of the buildings, particularly the chimneys that punctuate the skyline, are recognisable and are today a valued part of the town scene. The railway in the foreground in the earlier picture was then new (the Hastings–Ashford line was opened in 1851). It is now concealed by the Rye College buildings.

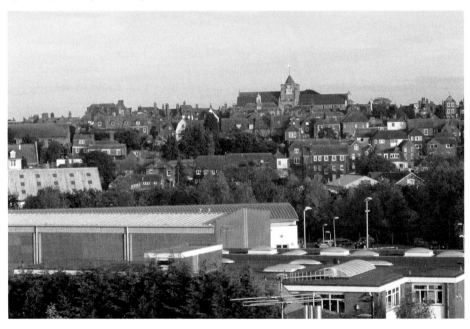

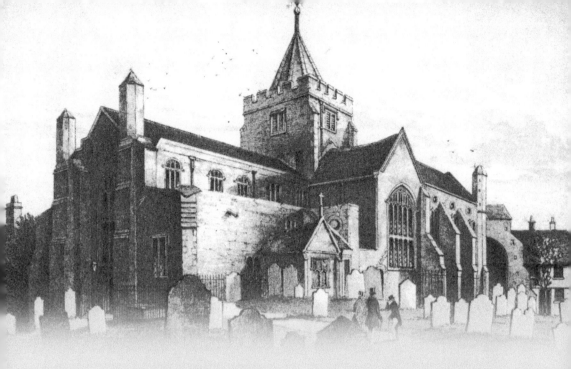

CHAPTER 2

Medieval Monuments

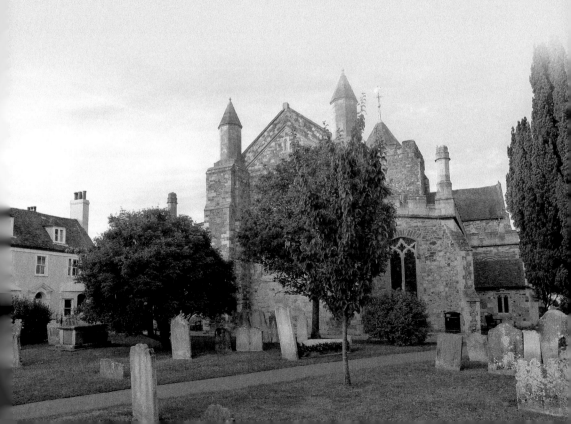

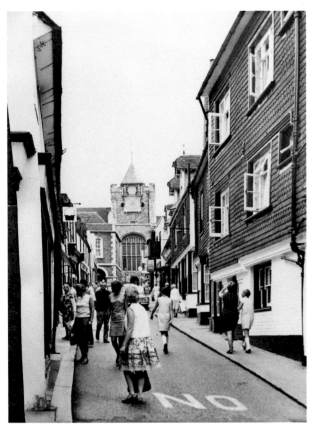

St Mary's Parish Church

Rye contained only one medieval parish. The church was founded *c.* 1105 at the highest point in the town, replacing an earlier building to the south. On the south side (see the previous page), the church is set in a churchyard now full of trees. To the north, the heart of the town is surrounded by streets thronging with visitors, both in the 1960s and today.

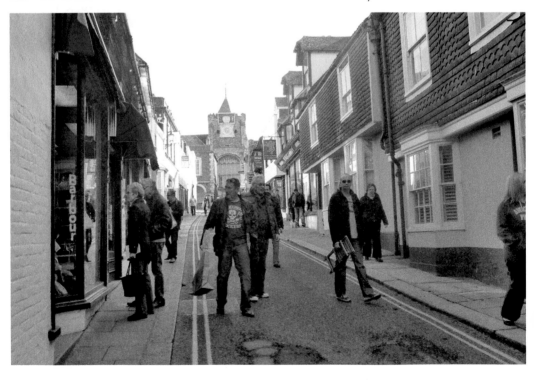

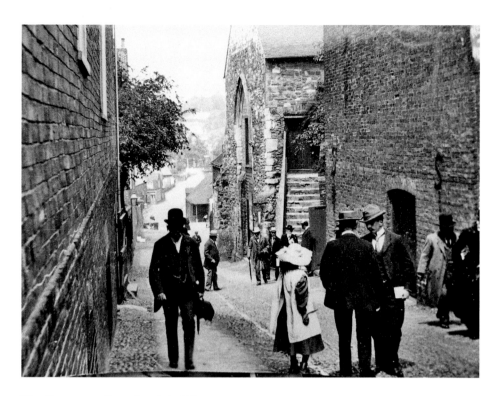

The Monastery from Conduit Hill

The chapel of this Augustinian Friary was built in 1378 on a newly allocated site to the east of the town following a landslip at its earlier location. It was later used as a wool store and the upper floor was approached by the external steps visible in both photographs. The earlier view shows members of an archaeological society visiting the town on 15 June 1901. Visitors still crowd this steep, cobbled street in much the same way.

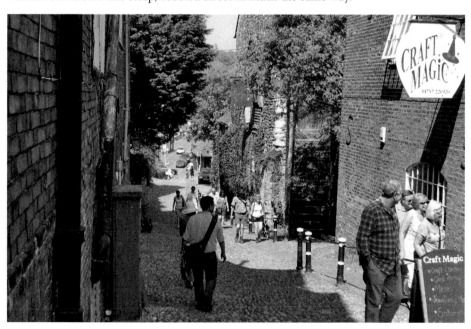

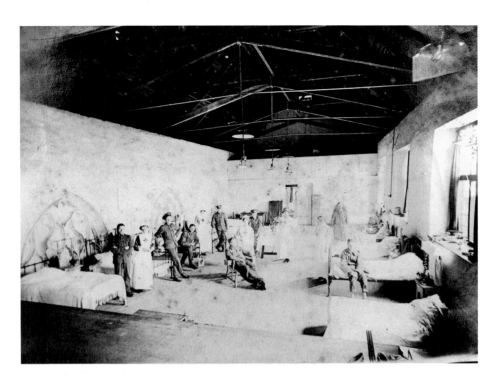

The Monastery Reused

In the First World War, the monastery was used as a hospital for wounded servicemen. It was otherwise used as a church meeting room and is still fondly remembered as a dance venue. After the Second World War, it became a pottery. It is now owned by developer Richard Williams, who is seeking an investor to open a restaurant or other commercial venture and to co-operate in a refurbishment. One suggestion is to reopen two of the blocked windows seen on the left in both photographs and form a gallery recess allowing light to flood into floor levels above and below.

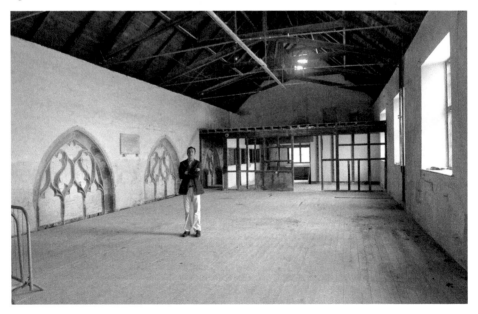

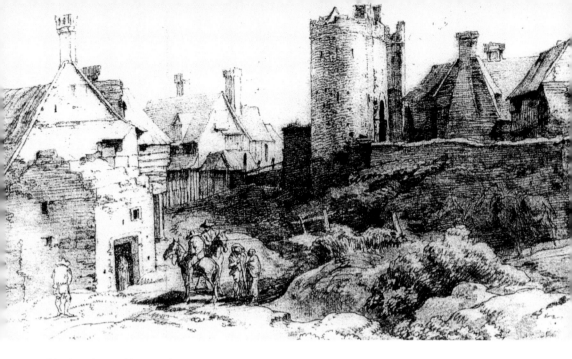

The Landgate Obscured

Rye's defences were rebuilt in stone in the fourteenth century and included three main fortified gates, one of which, the Landgate, survives. The remarkable early street scene above, by the court painter van Dyke, shows Tower Street from the west in the 1630s. The Landgate is still just visible above the nineteenth-century houses built on the site of the defensive town ditch. Other buildings in the distance are clearly recognisable, although altered. The small building on the left in van Dyke's drawing is possibly the pump house, part of the town's sixteenth-century public water supply.

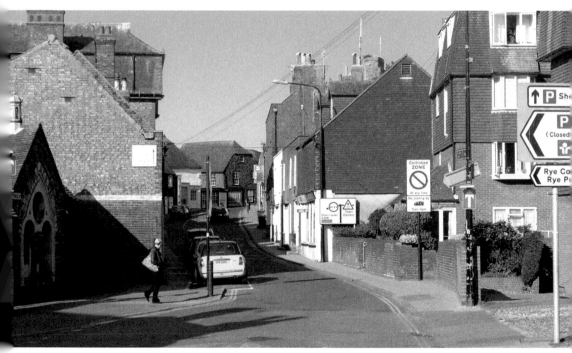

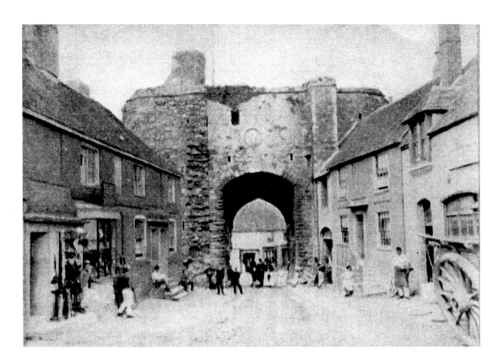

The Landgate Unchanged
This is a remarkable example of preservation and survival. Every building is unchanged from 1877 to the present day. The shopkeeper was Henry Miller, a toy and fancy goods dealer who started in business as a hairdresser in the Landgate *c.* 1860 and expanded to this second shop. Tower Forge, on the right, was occupied by Silas Winton, a blacksmith. It is now a craft shop and photographic studio.

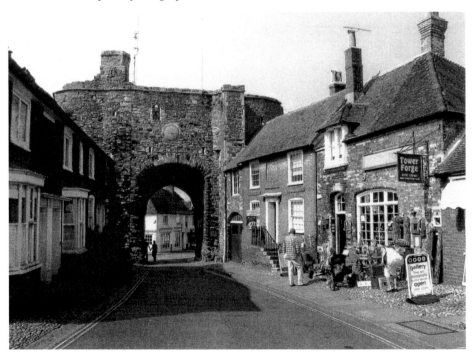

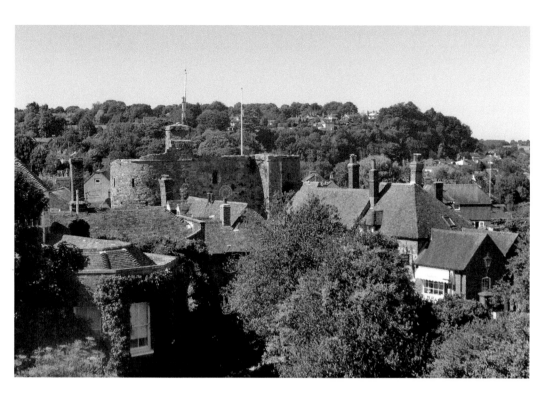

The Landgate from Inside the Town

This unusual view was taken from an upper window at the rear of a building in the High Street, probably in the 1860s, when Tower House was recorded by the Rye historian William Holloway as being derelict. Tower Forge is visible on the right in both pictures and in the background is Point Hill, then the site of a smock windmill, which was demolished in 1885. The site was redeveloped *c.* 1900 by the architect Sir Reginald Blomfield.

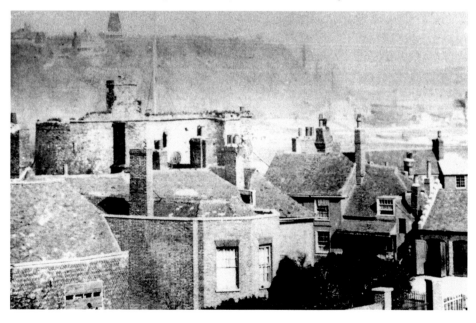

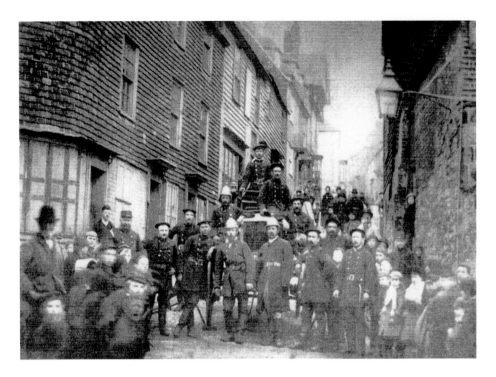

A Vanished Gateway

The Strand Gate stood at the junction of Mermaid Street and the Mint – to the left in the modern photograph. It is illustrated in Jeake's Map of 1667 as being similar in design to the Landgate. The volunteer fire brigade is seen here in 1890 with its eighteenth-century fire engine, now preserved in the Rye Castle Museum.

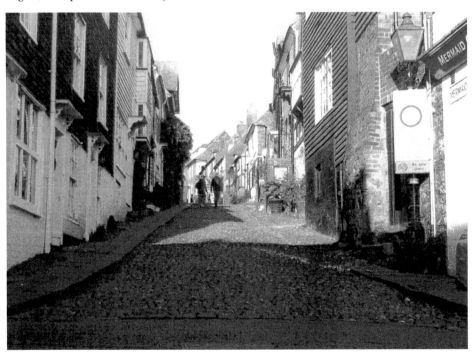

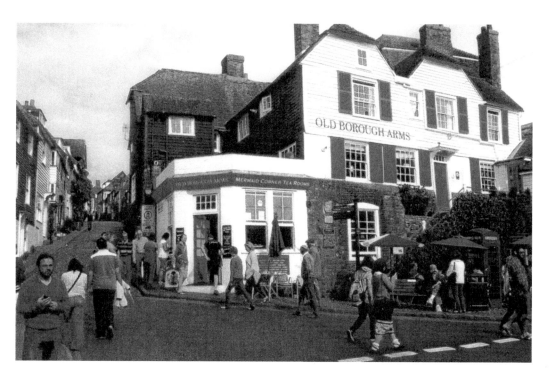

The Site of the Strand Gate

The gate stood at right angles to the Old Borough Arms, projecting out into the street in front of the Mermaid Corner Tea Rooms. It was demolished in 1815. The remaining buildings and the informal grouping of pedestrians on a busy day have changed very little from the time of the inter-war photograph.

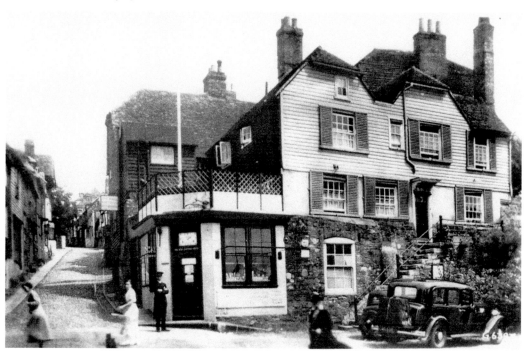

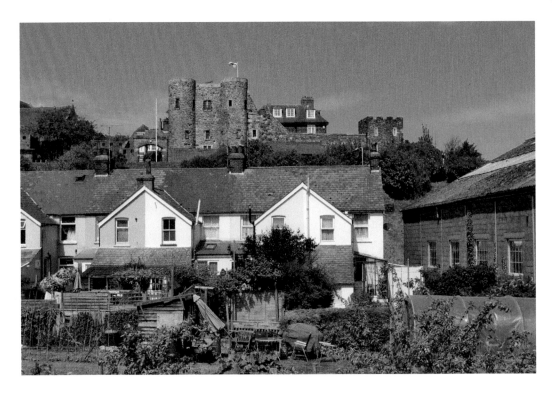

The Ypres Tower – Rye's Medieval Fortress

The tower was built at the vulnerable shallow-sloping south-east corner of the town facing the harbour and was joined by short lengths of the town wall. It is here seen in its modern context. Having been used as the town's prison, it was extended in a matching style in 1837 to accommodate women prisoners. A gun battery, remodelled in 1855, is just visible in both the modern-day and 1870 photographs. The muzzles are just visible above the parapet.

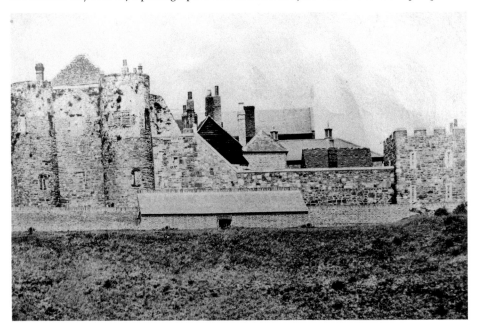

The Ypres Tower Reassessed

Traditionally dated to *c.* 1250, the tower has recently been the subject of an archaeological appraisal that has drawn parallels with similar construction details at the Landgate, also built integrally with the town wall and dating from the late fourteenth century. Construction during the latter phase is considered likely and a document of 1392 that guaranteed £120 between John Baddyng and three stonemasons may even provide an exact date. The Ypres Tower was used as Rye's court hall, a later version of which was built on the site of the present town hall in the early fifteenth century. At the same time, the tower was sold to Rye resident John de Ypres, whose name is still attached to it.

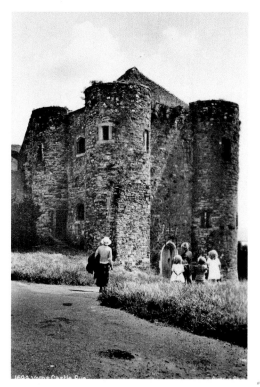

The tower was used as the town's gaol from the early sixteenth century to the 1890s, when efforts to conserve the building began. A society for the preservation of the town's ancient buildings was instrumental in the relocation of an unsightly soup kitchen to the pump house, seen on page 17. The building is seen in its pre-war form in the earlier photograph; the timber pyramid roof was added in 1552 and destroyed by a bomb in 1942. It is interesting to note the long grass, which contrasts with the inescapable tarmac of the modern era. In 1954, the tower became the home of Rye Museum, one of Rye's tourist attractions. The museum has refurbished the stonework with English Heritage support. The raised parapets that improve water run-off are clearly visible in the current image.

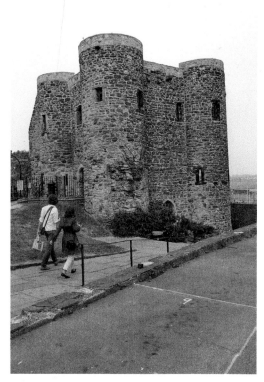

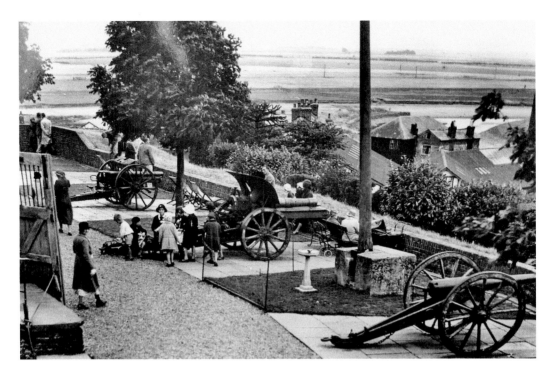

The Gungarden – A Historic Gun Battery

The first record of a gun on this site was in 1457–58. Batteries on this site and at an artificial mound at the Strand became permanent features of Rye's defences in the early sixteenth century. A timber enclosure is shown on the town map of 1772. In its present form, it dates from 1855, and in 1866 it was in the care of John David Morton, listed in a trade directory as master gunner of the Royal Artillery Coast Brigade. The inter-war photograph shows captured German guns placed here after the First World War. The current photograph shows replica cannon cast in Rye at Rother Ironworks in 1982.

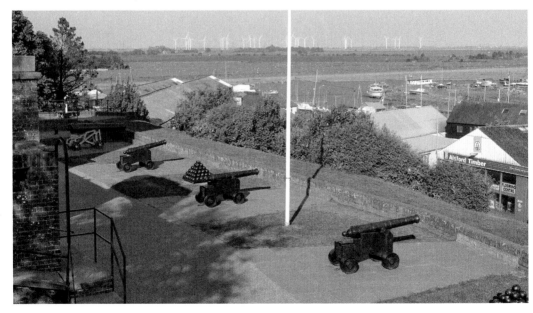

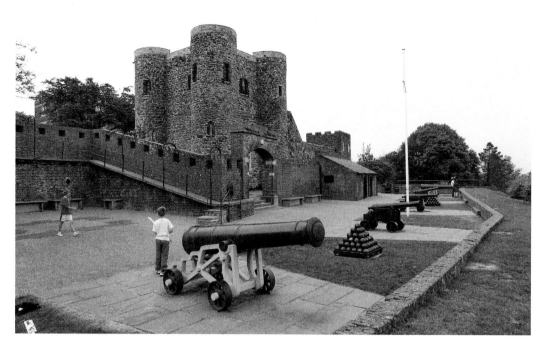

The Gungarden Refurbished

In the late 1990s, the owners, Rother District Council, commissioned the restoration of the site as a historic gun battery, after a post-war phase as a municipal garden. The former stone gun platforms and gravel surface were replaced, together with replica cannon and ball stacks. The foundations of the eighteenth-century magazine were excavated and picked out in the new paving within the 1855 musket wall.

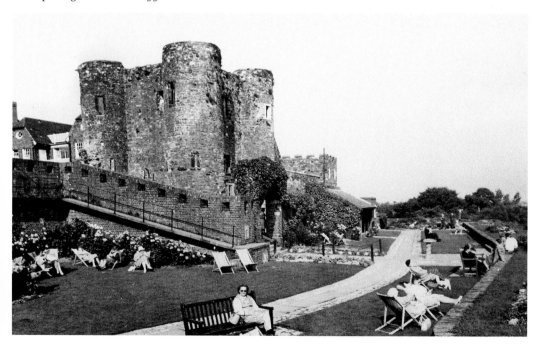

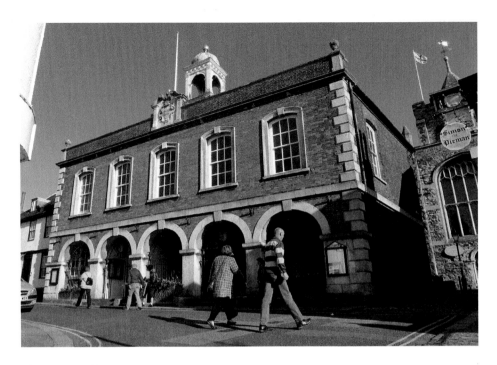

The Town Hall

The court hall at this location – dating from the fifteenth century – was rebuilt by the corporation in 1742 to the design of a London architect, Andrews Jelf. The building is an elegant example of a Georgian town hall with an arcaded market beneath. The drawing dates from *c.* 1825 and later alterations have been restricted to the infilling of two of the arches to form offices.

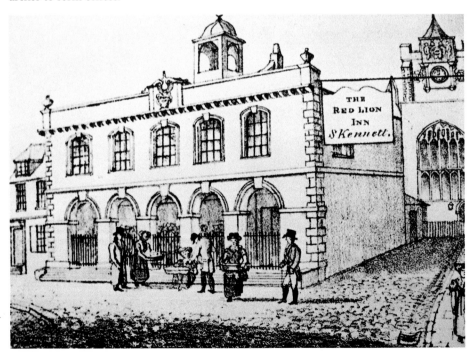

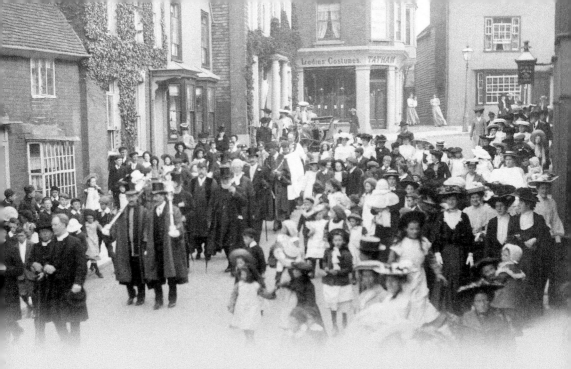

CHAPTER 3

Life in a Historic Town

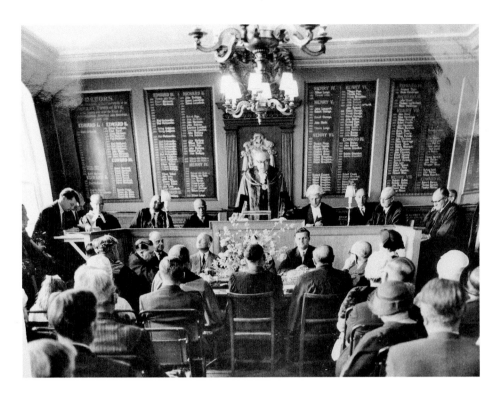

Local Government

Rye has a long history of proud self-government as a Cinque Port. The previous page shows a civic procession in East Street in 1906, when the refurbished monastery was dedicated to church use. The photograph above shows the installation of Ronald Reynolds as mayor in the 1960s. Some of the councillors appear to be giving the speaker less than rapt attention! The photograph below shows the town council's planning committee meeting under the chairmanship of Frank Palmer on 26 April 2011.

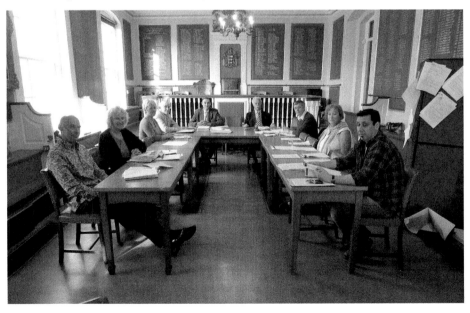

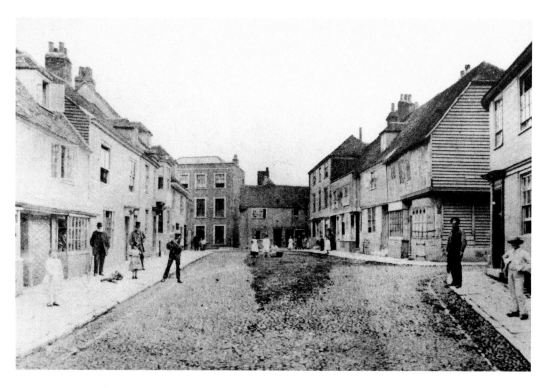

A Traffic-Free Street

The wide road at Market Street was the site of part of the medieval market. The large house in the background was built in 1816 and is timber-framed – being brick at the front only. Most of the other buildings are medieval. In the 1860s there was not a single vehicle to be seen. This is impossible to achieve today in a small, tightly built town with little off-street car parking.

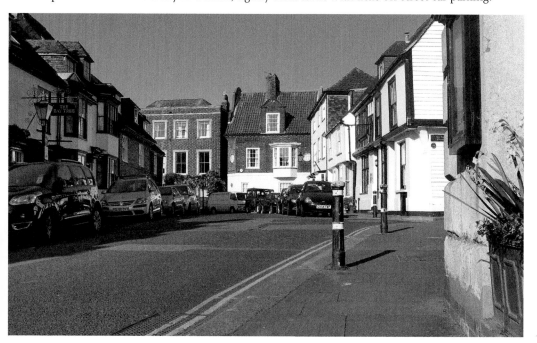

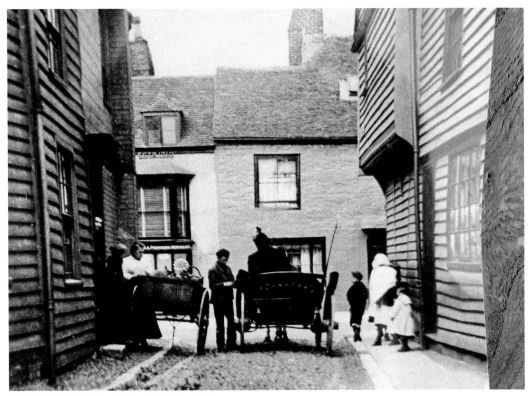

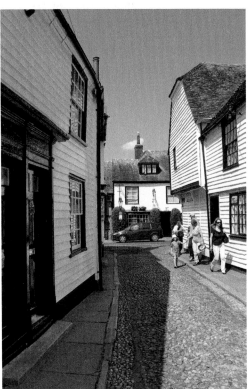

Horse-Drawn and Hand Carts in Pump Street

Here we see the junction of Pump Street and Market Street *c.* 1910. This is a charming study of a lady in a dog cart buying from a trader with a hand cart, passed by children on foot. The buildings are very little changed and include the Flushing Inn on the right, a corner building of *c.* 1525 with a well-known wall painting. It was later the home of Rye murderer John Breeds, who was hanged in 1742 and whose skull is still preserved in its gibbet in the town hall.

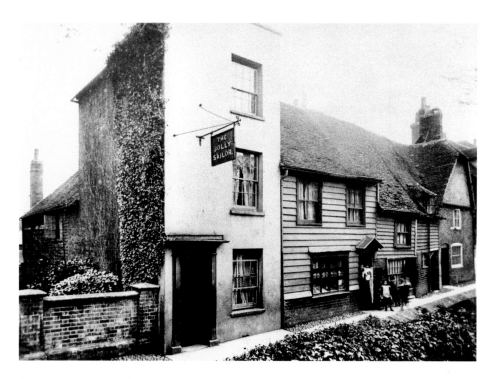

Changing Status – Church Square

The medieval timber buildings on the south side of Church Square were in-filled to a greater density in the sixteenth century. By the Victorian period, the buildings were further sub-divided, and were densely packed with the poorest Rye fishermen and labourers and their families. The Jolly Sailor was built in 1838 to accommodate passengers travelling by steamer to France. The inn later became a poor travellers' lodging house. The timber-framed fronts were built in the 1920s by an investor named McDonnell. It is pictured here with current owner June Bearman.

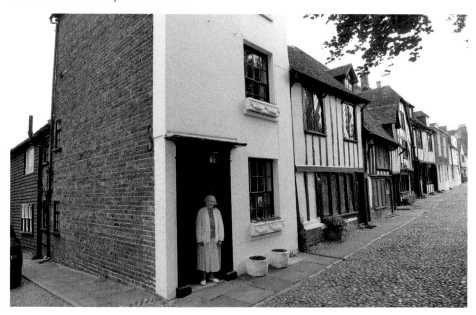

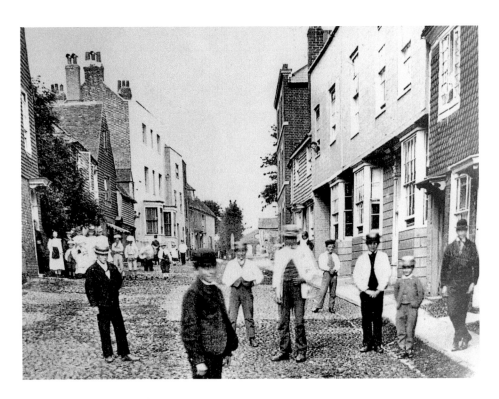

A Social Mix – Watchbell Street

In the Edwardian photograph, this famous cobbled street displays a variety of headgear and clothing. The occasion is not known, but reflects the mix of statuses among the residents, who included wealthy shipbuilders, solicitors and mayors living cheek-by-jowl with poor fishermen. In common with other streets, there is now a combination of full-time and second-home residents.

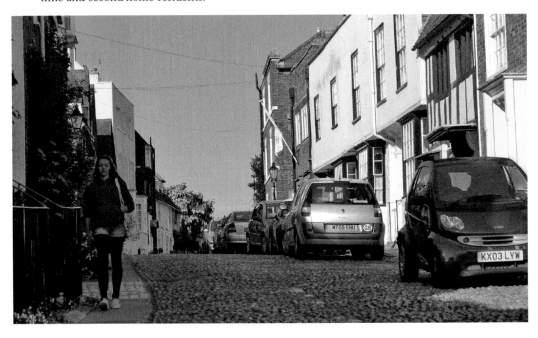

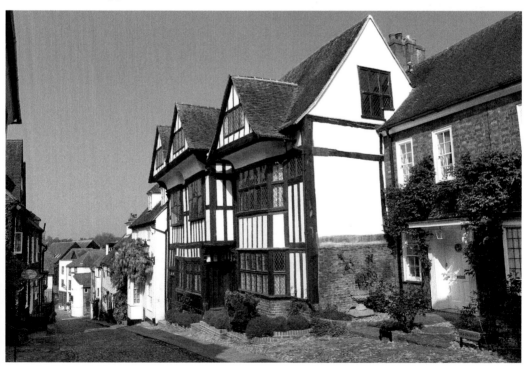

Changing Fortunes – The Old Hospital
Perhaps the best-known of Rye's historic cobbled streets, Mermaid Street, would have been demolished if the disrepair evident in this 1860s photograph had been allowed to progress. In 1859 this impressive merchant's house, built in 1576, was sub-divided and empty. By 1872 it was restored as and named Jeakes House after its seventeenth-century owner, the merchant, diarist and astrologer Samuel Jeake the Younger. The name is now applied to his storehouse.

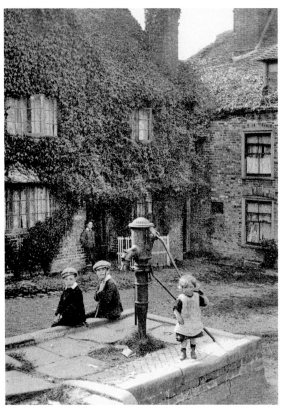

A Sixteenth-Century Suburb – Landgate Square

In the town's period of prosperity in the sixteenth century, this area developed around a square centred on the later communal pump. In 1859, the square was sub-divided into eleven households. At the time of the Edwardian photograph, these included the Rhodes, Fowle and Amon families, who earned a living independent of single employers by working seasonally in fishing, gathering and labouring. The pump and cistern housing have survived unchanged – apart from weeds.

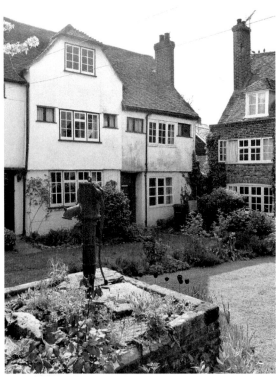

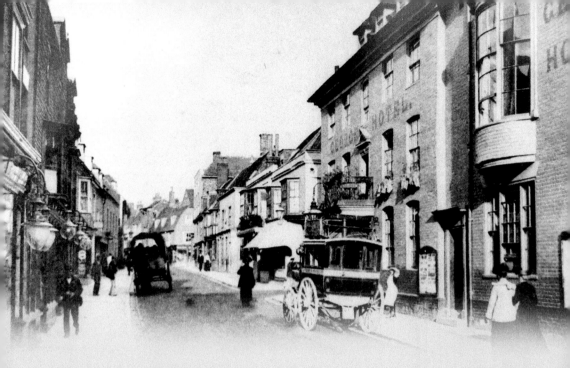

CHAPTER 4

High Street

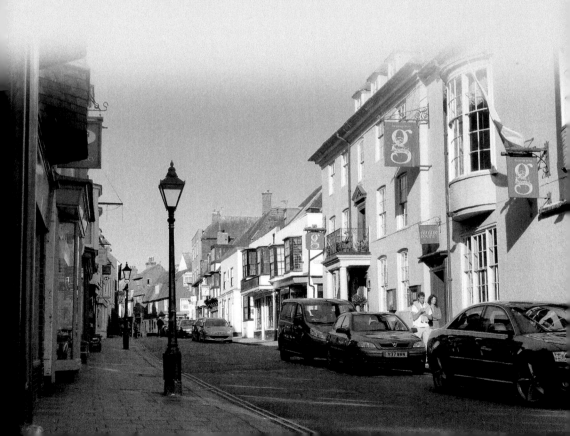

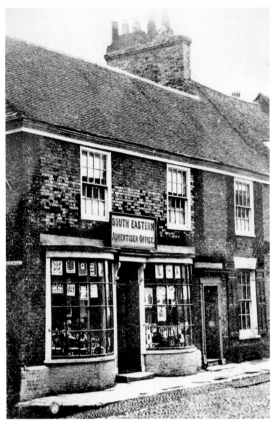

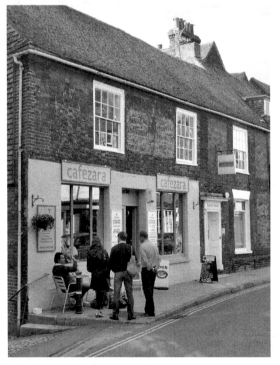

Late Medieval Development at the East End of the High Street

The previous page shows the length of the street, which retains some buildings from the earliest period of survival in the town, c. 1400. The area on this page was then open ground. The south side of the street was common wasteland until 1486–90. The north formed part of the grounds of the monastery in Conduit Hill and was probably developed by the friars c. 1500. This present building dates from the eighteenth century. It was empty in 1859, but by 1867 was occupied by Isaac Parsons, printer, bookseller and stationer. He was also proprietor and publisher of the local newspaper, which is advertised prominently above the door. The window displays, resembling modern dust jackets, have a surprisingly modern appearance. By 1882, Parsons & Cousins had been succeeded by James Cole. He in turn had by 1890 been succeeded by Joseph Adams, who also rejoiced in the post of inspector of nuisances to the Urban Sanitary Authority. He was later mayor and was author and publisher of a series of guidebooks to Rye. His business, still known as Adams of Rye, is now owned and run by Clifford Foster and his son Ian and is located at No. 8 on the opposite corner of Conduit Hill. This building is little altered and is now occupied by Café Zara, F. A. G. Menzies, land agent, and Manning Duffie, architects.

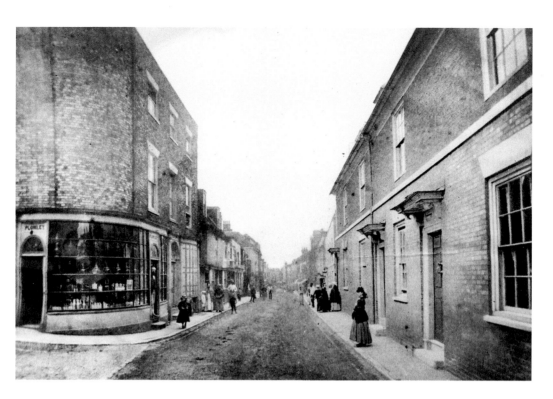

Georgian Redevelopment

Both buildings in the 1850s photograph were built on cleared sites. The bow-fronted building on the left had a long history as a chemist's, apparently from 1787. James Plomley is listed as proprietor from 1839, and he was joined in partnership from 1859 by Waters. The shopfront and internal fittings are particularly fine features. The building is now the Apothecary Coffee House. The terrace on the right was built in 1736 by James Lamb, a wine merchant, as three houses over massive brick barrel-vaulted wine cellars.

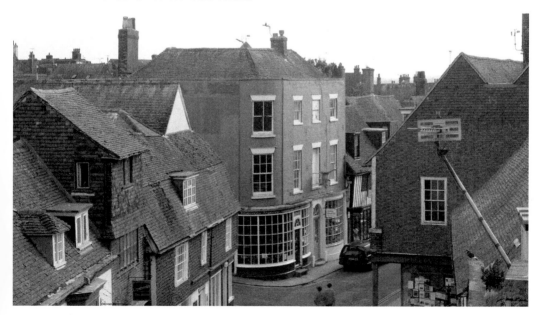

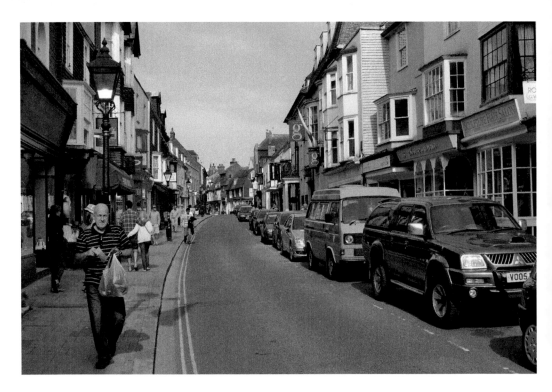

A Busy Shopping Street

There is remarkable continuity in the buildings, evident in these views looking east in the Edwardian period and today. The change lies in the parked vehicles – a bicycle, horse-drawn and hand carts, and an early motor car in the old photograph, cars in a one-way system in the modern.

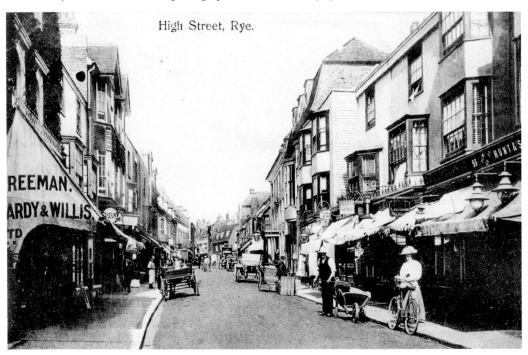

High Street, Rye.

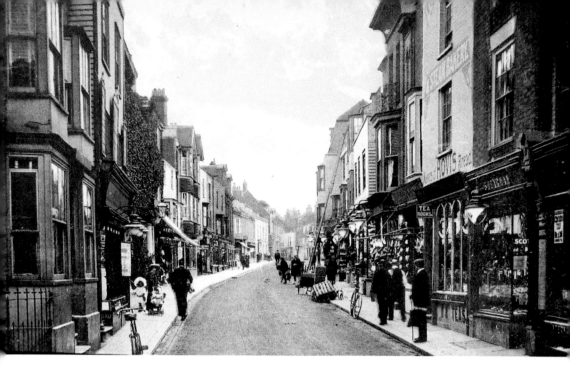

Another View Further West

The buildings are almost identical in both photographs and form a treasured Edwardian shopping street of buildings mainly reconstructed in the early nineteenth century, with some survivals from the Tudor period. Another common thread is the informal throng of pedestrians of all ages straying into the carriageway – then as now!

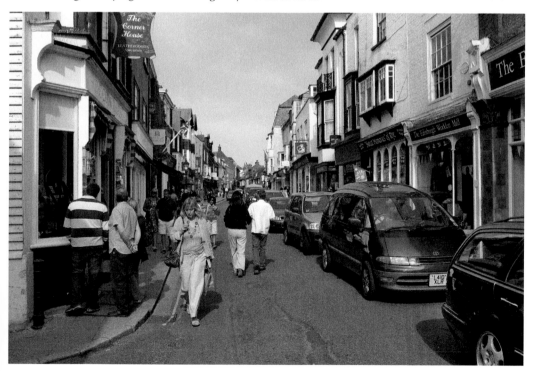

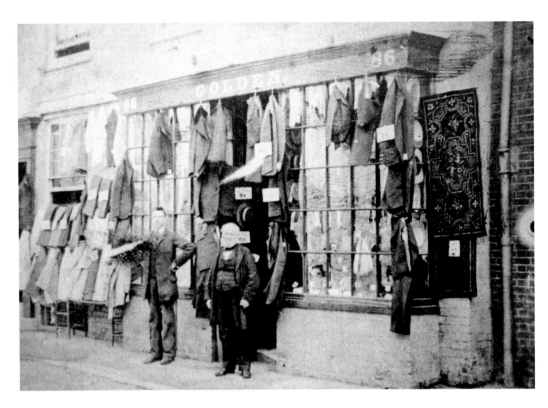

A Long History as a Clothing Shop

No. 86 is an early nineteenth-century double-fronted shop with mathematical tiled façade. Sadly, the shopfront has not survived. William Golden was listed as a clothier at the Strand from 1858 and at this shop from 1874. The 'Golden' name was attached to the business until the 1980s. It was recently taken over by Rye Shoes.

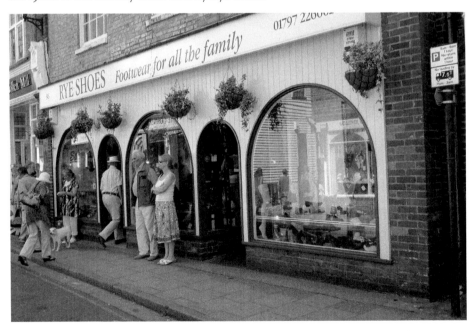

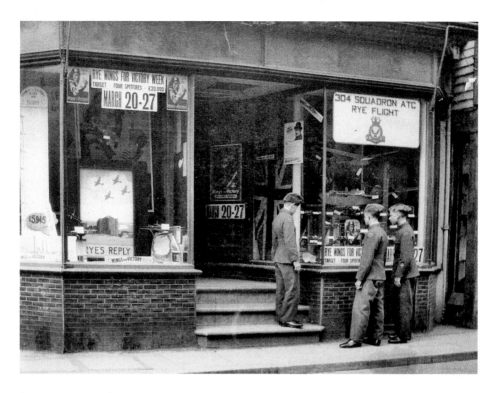

Temporary Wartime Use

No. 27 was the offices of Reeve & Finn Auctioneers between *c.* 1890 and 1920. It was listed as empty in 1940 and was taken over for the fundraising campaign of Rye Wings for Victory Week, part of a national campaign of local events between March and June 1943. The local Air Training Corps appear to have been involved. The 'Rye's Reply' poster shows four spitfires flying over the Ypres Tower. The building is now a leather goods shop.

The Western End of the High Street

This is another example of continuity in the buildings. The post-war photograph shows early multiples Mence Smith (ironmonger's), Flinns (dyer's and cleaner's) and Boots (chemist), all established in Rye in the 1930s. A reserved parking bay is marked on the road behind the first car. In the modern view, the multiples have given way on the left to local independent businesses Rye Delicatessen and Simon Milne Jeweller.

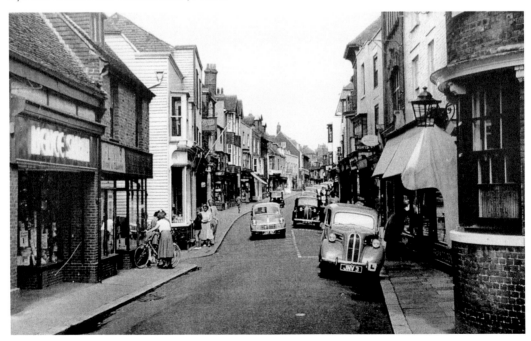

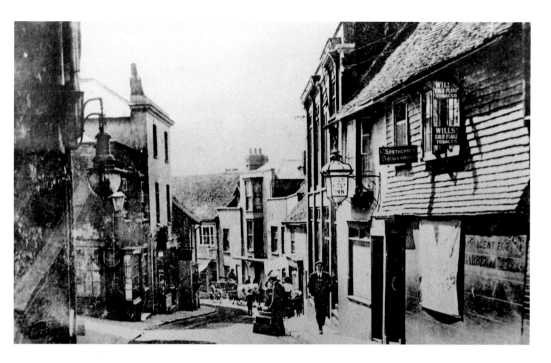

The Mint Looking West

This street forms a western continuation of the High Street and contains the oldest surviving building in the street, the Old Bell Inn, and an adjoining shop on the right dated to *c.* 1400. The inn was enlarged to include the site of the two-storey china warehouse in the 1930s.

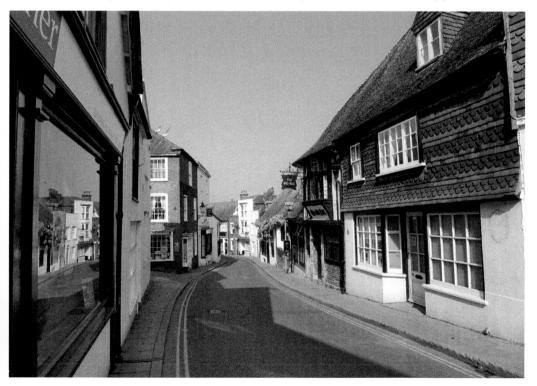

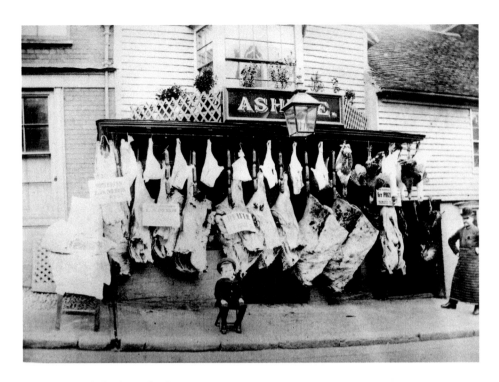

A Long-Established Butcher's

Henry Ashbee started trading in Ferry Road in the 1880s before moving to this shop at 2 East Street just off the High Street *c.* 1890. The business moved again in the 1900s to 100 High Street, where it has now only recently closed. Note the continuity in roof planting. The building on the left was a house owned by Stephen Fryman, a wine merchant who converted the covered access to the store *c.* 1913. This building was acquired by Rye Museum as a second display site in the 1990s.

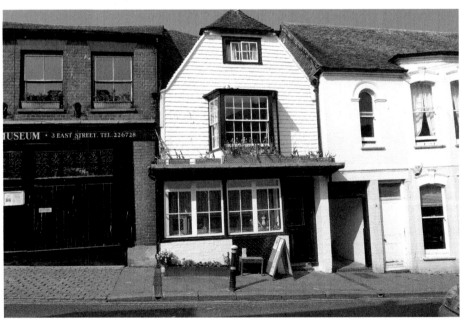

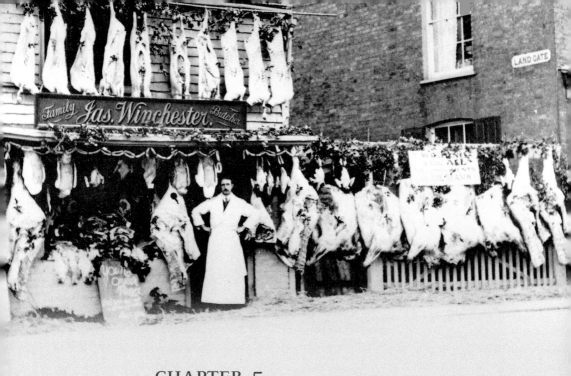

CHAPTER 5

Other Commercial
Streets

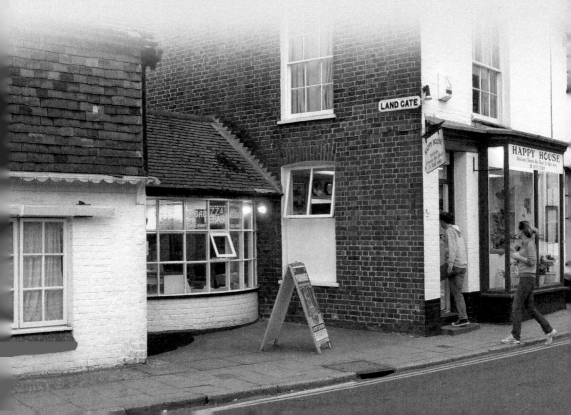

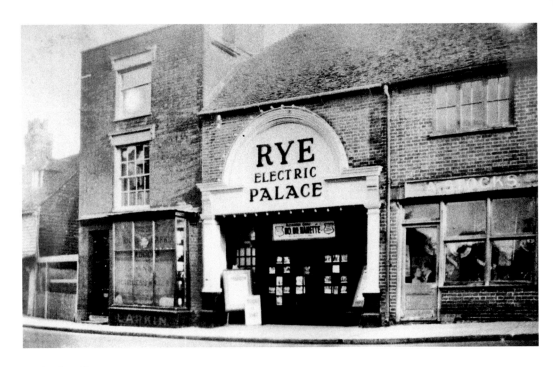

Rye's First Cinema

Landgate was a sixteenth-century suburb of Rye. The previous page shows James Winchester's butcher's display at No. 16 at Christmas 1928 or 1929, and the current photograph shows takeaway food outlets. The Rye Electric Palace on this page opened in 1912 and closed in 1932, when the owners built the first Regent Cinema in Cinque Ports Street. The musical *No, No, Nanette* was first made into a film in 1930.

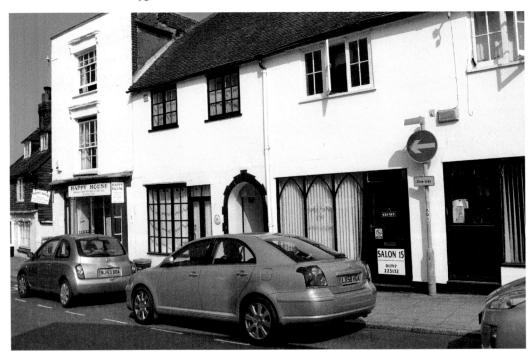

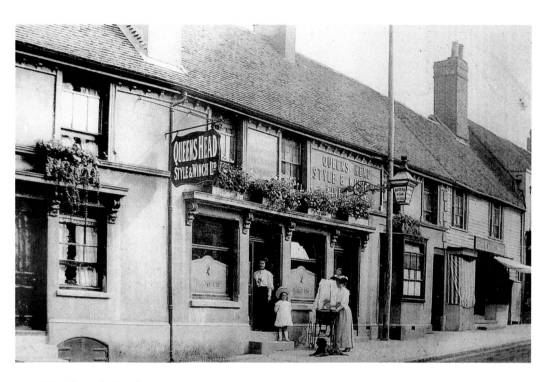

The Queen's Head

Nos. 18 and 19 are occupied by this public house, the northern part of a speculative terrace of six cottages built *c.* 1575. The Queen's Head was one of only six inns in Rye in 1824. This number had increased to twenty-two by 1839. The corbelled canopies and eaves probably date from a change of landlord in the 1880s, before which the building had a Georgian appearance.

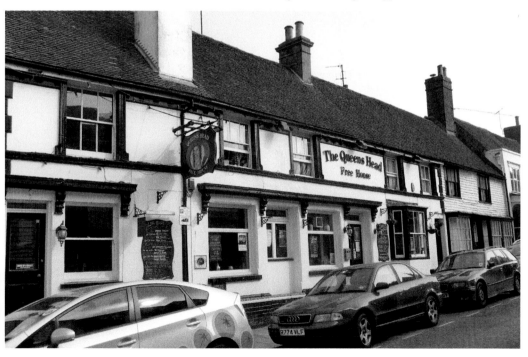

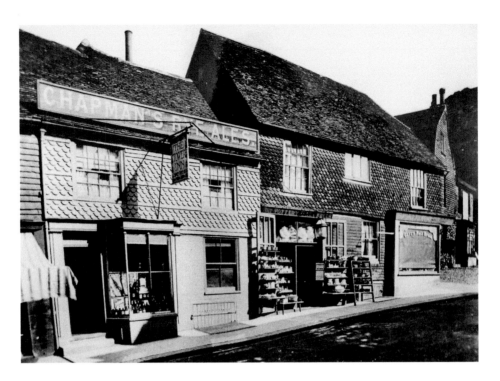

The Tower Inn

No. 23 occupied the northern end of the sixteenth-century terrace. Its use as a public house dates from the proliferation of beerhouses in Rye in the mid-nineteenth century. It was closed after 1901 under an Act of Parliament restricting the number of public houses. No. 24 on the right was built *c.* 1540. It was occupied in the 1900s photograph by Art Pottery Galleries and F. J. Thompson, baker. It is now the offices of Gibbons Mannington & Phipps, Chartered Accountants.

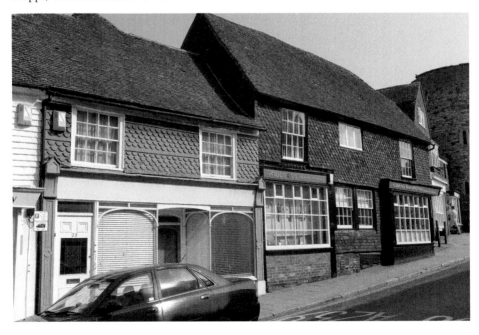

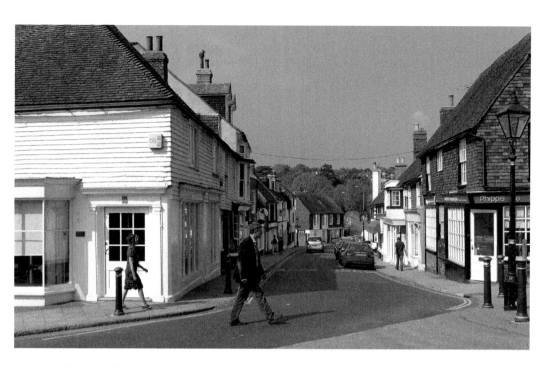

Landgate Looking North

This view out of the town from the Landgate Arch shows the main approach road into Rye. The south side of the street is on the left, including No. 1, a linen draper's occupied by George Edwards from before 1839. He was later joined in partnership by his nephew, George Gibbs Edwards, who is pictured here in the 1870s with a display of hats. Most of the buildings beyond date from the nineteenth century.

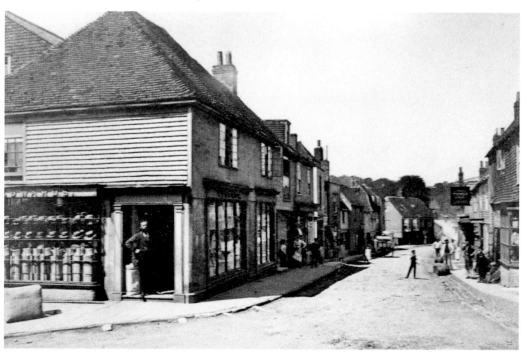

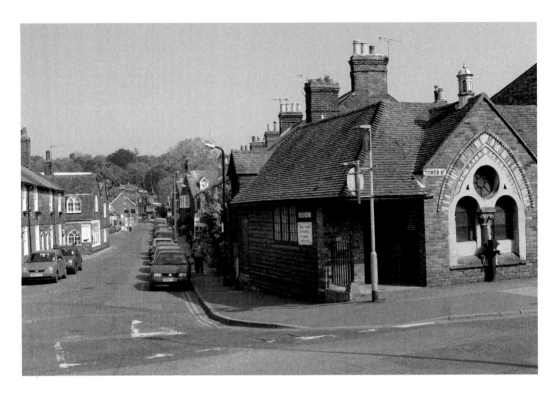

Rope Walk

This street was a secondary approach to the town through the postern gate in the town wall. The building on the right, above, was the town's pump house, part of the sixteenth-century water supply. This depended upon springs below Rye Hill. The terraced housing dates from 1830 on the left and *c.* 1900 on the right and beyond.

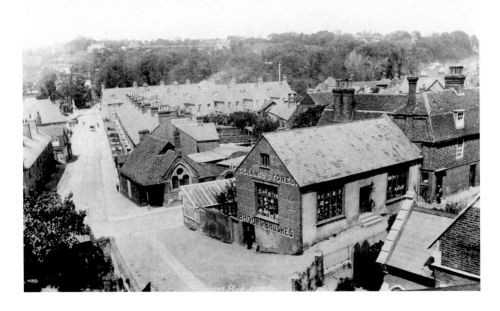

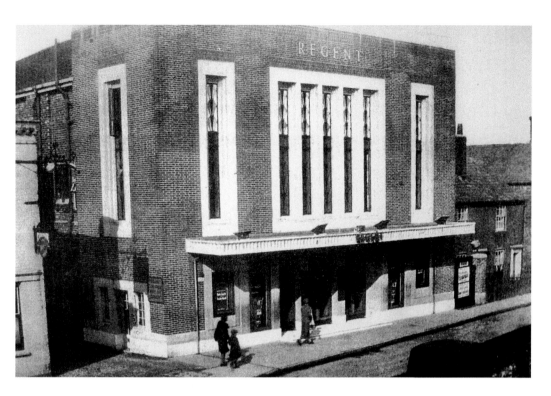

The First Regent Cinema

Cinque Ports Street is a commercial road that grew up over and beyond the town ditch in the nineteenth century. The Regent Cinema was built in 1932 replacing the Electric Palace. It was destroyed by enemy action in 1942 and rebuilt. The cinema closed *c.* 1980 and was replaced by a parade of shops and housing by local developer Patrick Osborne.

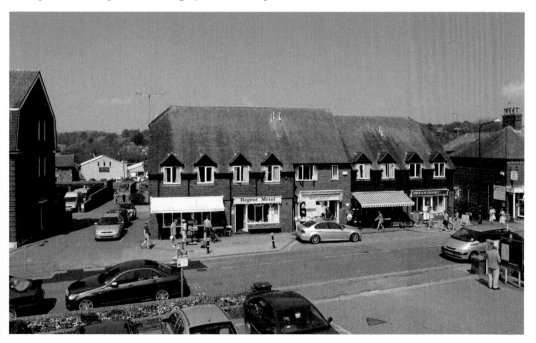

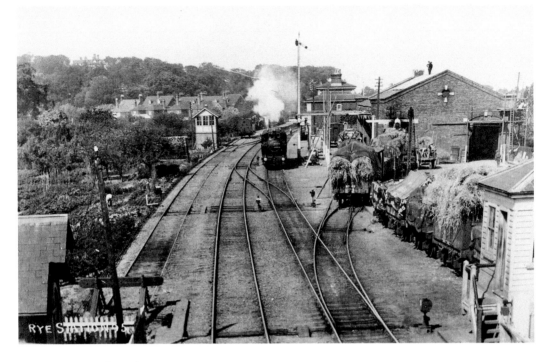

Rye Railway Station

The Hastings-to-Ashford line was opened in 1851. The elegant Italianate station is a listed building and survives together with the signal box to the left. The goods shed shown in the Edwardian photograph with hay carriages in front was unfortunately demolished in 1984 and the site was taken over for a one-way road around a supermarket development.

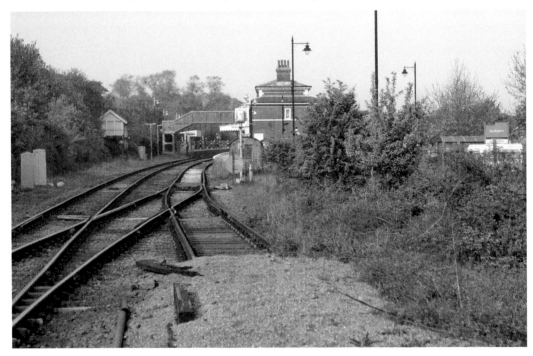

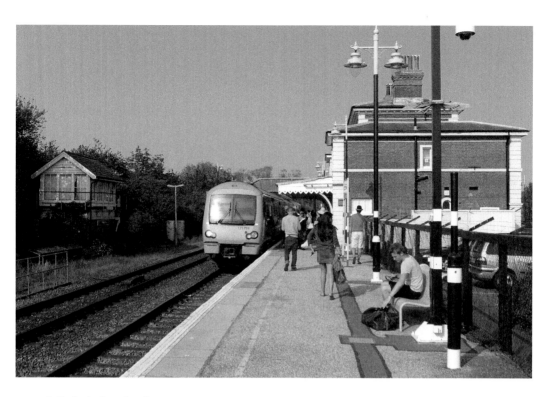

A Train in Rye Station

Apart from the change from steam to diesel, very little has changed between these views, which are separated by over ninety years. The motor train or 'push-pull train' introduced in the early 1900s was designed to drive in either direction without moving the engine between the ends of the train. There was a small driving compartment at one end. The card is post-marked 1920.

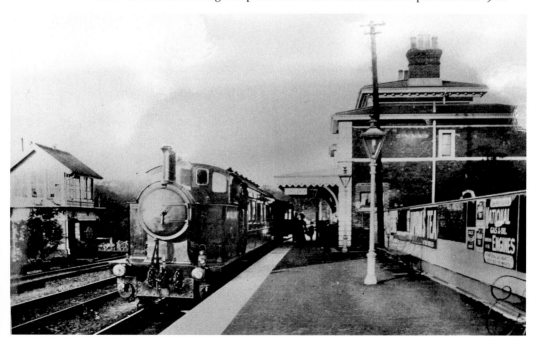

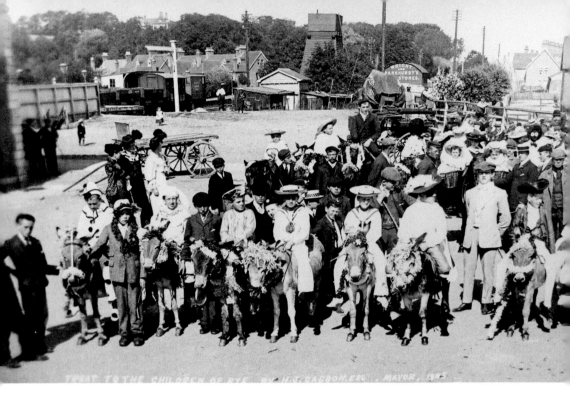

TREAT TO THE CHILDREN OF RYE BY H.J.GASSON.ESQ MAYOR, 1905

Rye Station Approach

The area in front of the station was a wide drive from Cinque Ports Street, now part of the one-way system around Jempson's/Budgens Supermarket. It is also a taxi rank. It was the scene of part of Mayor Henry John Gasson's treat to the children of Rye in 1905.

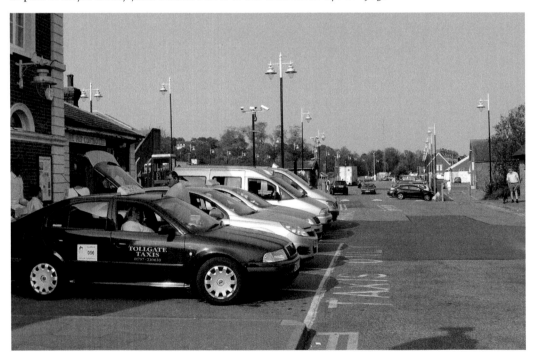

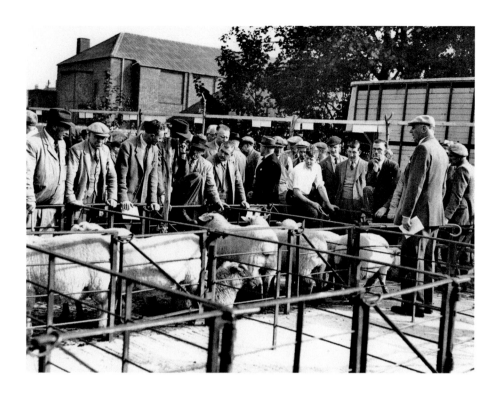

Rye Market

The cattle market moved from Market Road to a large new site adjoining the railway in 1859. Paving and cast-iron pens were laid out and a market house was built for indoor sales. A second building was added, first known as the Agricultural Hall, now the Rope Walk Shopping Arcade. Livestock sales stopped in the 1980s. General markets continue on Thursdays and Bank Holidays.

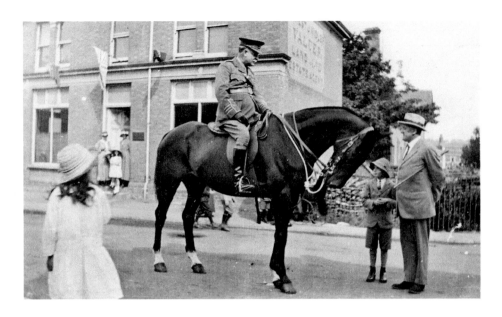

The Estate Offices

Vidler & Co. estate agents occupied this building at 20 Cinque Ports Street from its construction in *c.* 1900 until the firm's acquisition by Prudential in 1989. It is now the Rye office of Rush, Witt & Wilson, whose Ralph Popple is pictured here with a colleague. The horseman is George Courthope, MP for Rye and a Territorial Army colonel. The occasion is the Coronation of King George V in 1911.

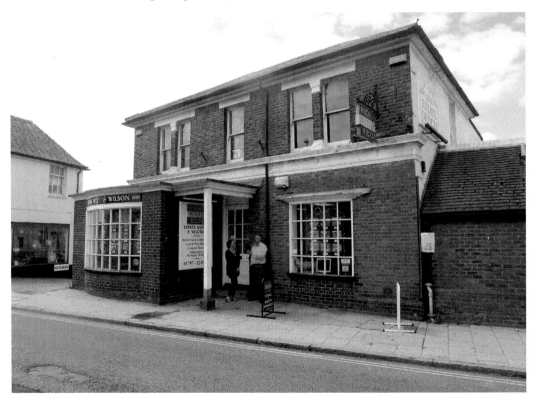

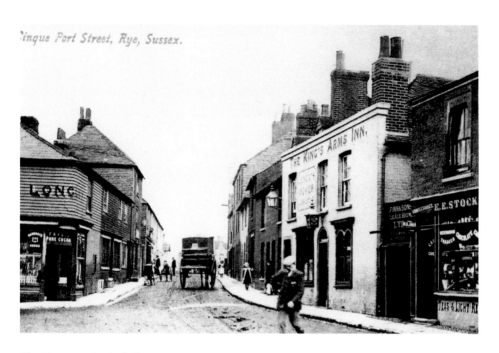

The Western End of Cinque Ports Street

This end of the street is joined by Ferry Road at the western approach to the town. The King's Arms Inn was another public house, closed after 1901. It has been demolished and replaced by Cinque Port Antiques. Also gone is Longley's Grocery Shop after war damage. The number of road signs is the striking difference between the photographs.

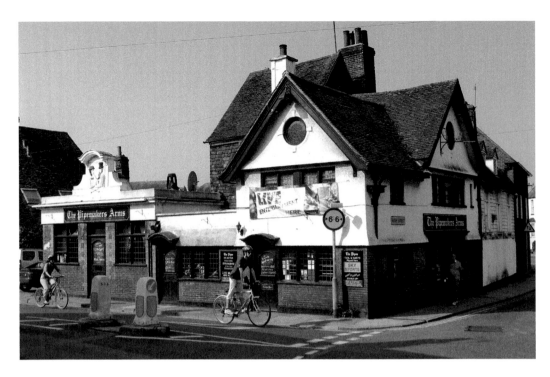

The Pipemakers Arms

This public house at the junction of Wish Street and Wish Ward is pictured in the 1900s before inter-war alterations and an extension, which included a tall, covered gateway on the Strand for motorist customers. The row of cottages behind was largely destroyed in the Second World War; one remains as part of the public house.

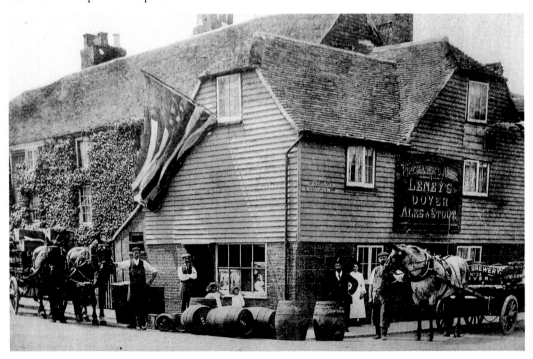

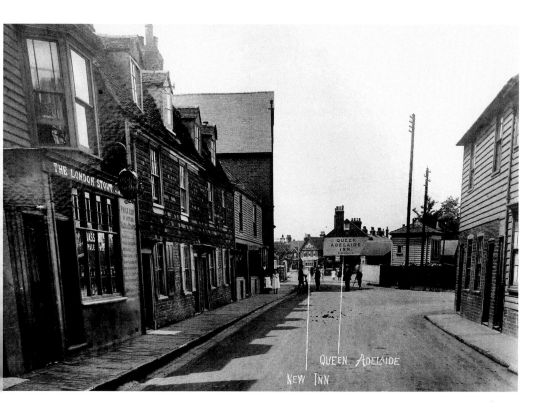

Three More Public Houses

The upper photograph illustrated an enquiry into the closure of public houses in the 1900s. The New Inn (later the Ferry Boat) and the Queen Adelaide survived the review. The London Stout, an eighteenth-century building at 32 Ferry Road, did not. It is now a singing studio owned by Sandra Scott, who is pictured here with her daughter Martha.

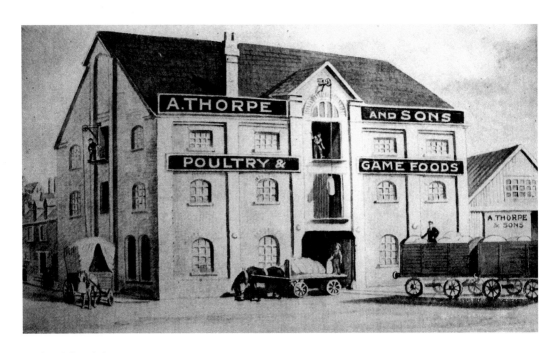

Rye's Night Club

Albion Thorpe's corn and hop warehouse in Ferry Road was first listed in 1887. The business was described after 1918 as a poultry-food manufacturer. The railway siding into the building, complete with trucks, is not shown on any maps of the period. The building became a nightclub in the 1970s.

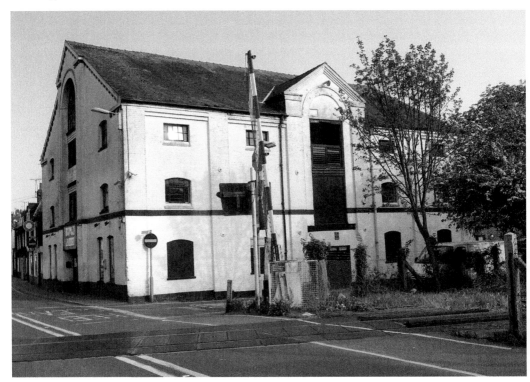

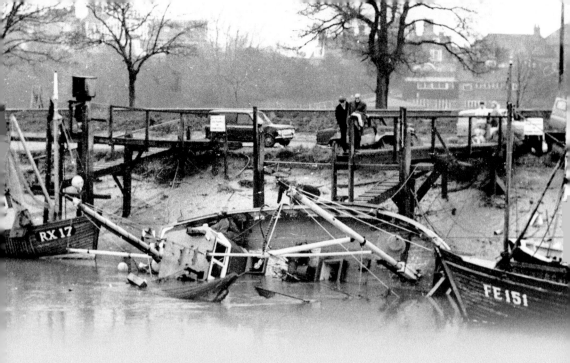

CHAPTER 6

Rivers and Quays

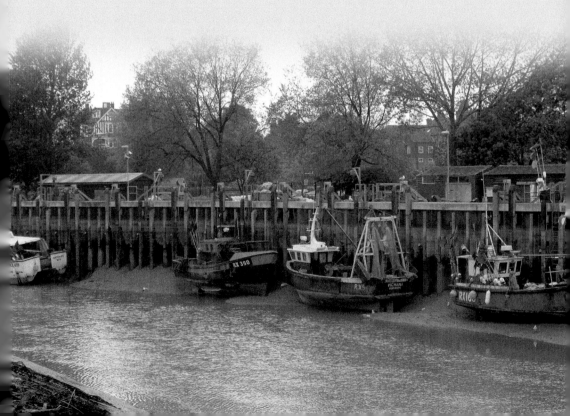

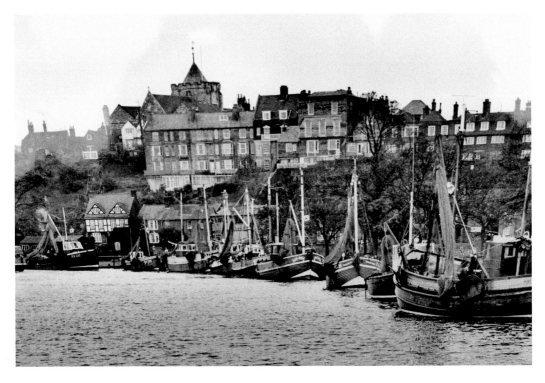

The Fishmarket from the East

Both views show the buildings at the top of the town, but the piled quay and linear buildings of the 2006 improvements have created a more utilitarian appearance, both on this and the previous page, which includes a capsized fishing boat, apparently in the 1960s.

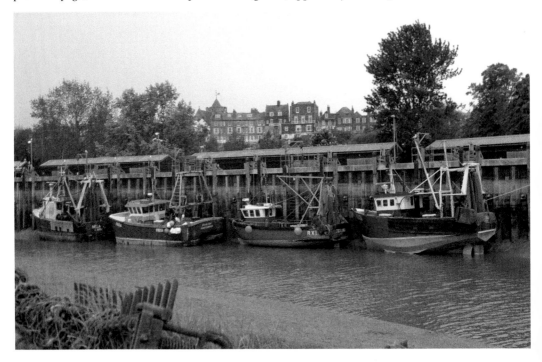

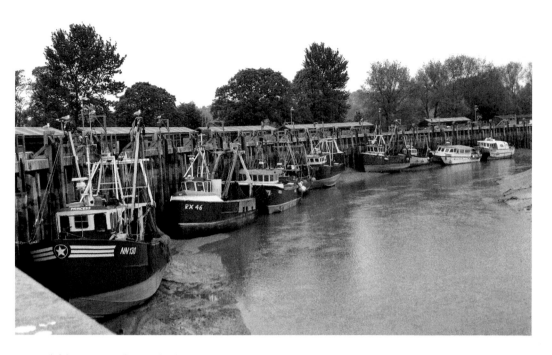

Fishing Boats alongside the River Bank

The modern view shows motor trawlers at the 2006 piled quay at low tide. The view from the 1890s has the mudbank exposed at a similar stage of the tide, with sailing smacks tied to mooring posts. RX48, to the right, was built in 1880 and owned by Vidler & Sons. The small boat is probably the ferry, which provided access to the east bank of the river.

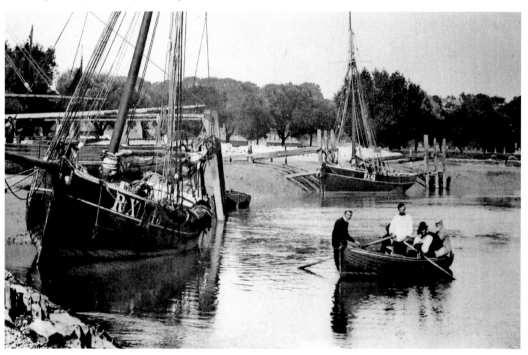

Shore View of the Fishmarket

This photograph probably by the amateur Hastings photographer George Woods in the 1890s shows the Fishmarket quay, looking north, and a moored sailing smack. The embankment alongside the quay dates from the enclosure of the saltings in 1834. The modern view shows the change to a bustling, well-equipped quay enclosed by a steel fence.

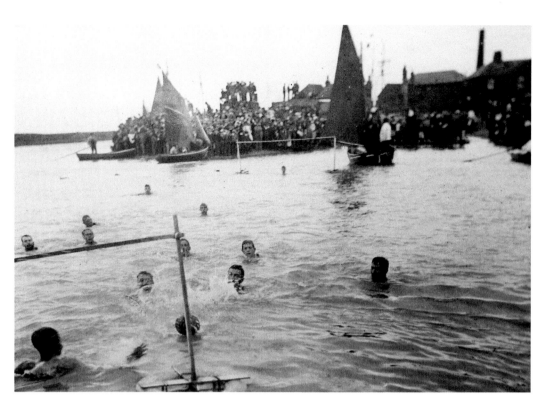

Water Sports

The Rye historian Leopold Vidler records the revival of the Rye Regatta; a team water polo team found that 'the chief trouble was to keep anywhere between the goal posts owing to the downward set of the tide'. In modern times, the annual Rye Raft Race at the Fishmarket has been the main fundraising event of the Rye Lions for nearly thirty years.

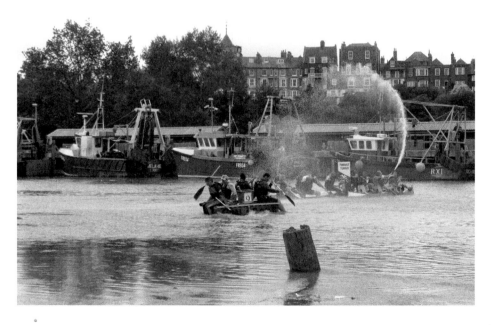

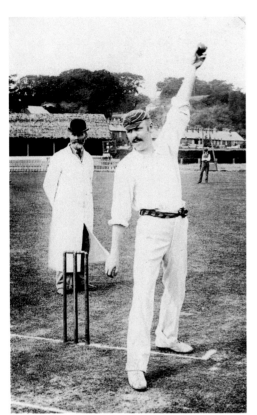

Cricket on the Salts

Rye Cricket Club is one of the oldest in the country, having been established in 1754. The present ground on the salts adjoining the Rother dates from after the Embankment Act of 1834. The bowler and umpire in the old view have not been identified, but the clothing, including the cap with small peak and the everyday shirt with sleeves rolled up, suggests a date before the First World War. The photographer is looking north towards the houses in Military Road, with Point Hill beyond. In the background there is a horse-drawn roller and a framework for the scoreboard in front of the thatched pavilion. A 1907 map shows the fenced enclosure. By 1927 this had gone and the facilities included a tennis court and bowling green on either side of the pavilion. A sunken swimming pool on the river side of the embankment was filled and flushed by the tide. The current photograph shows club historian and secretary Martin Blincow in a similar pose. The club has four teams in the East Sussex Cricket League – a Sunday team, a mid-week friendly team and two Twenty20 mid-week teams – plus four colt teams for juniors.

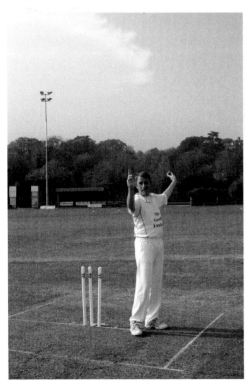

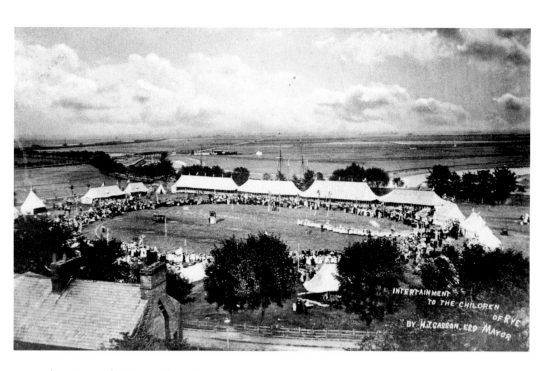

The Town Salts Recreation Ground

The 1834 enclosure of the saltings, previously flooded at high tide, provided space for a recreation ground immediately east of the town. This was the venue for a lavish entertainment for the children of Rye by Mayor Henry John Gasson, a tent and marquee dealer and contractor, in 1905. Beyond the river, the Rye station of the Rye & Camber Tramway has been replaced by housing and a school (now an arts centre).

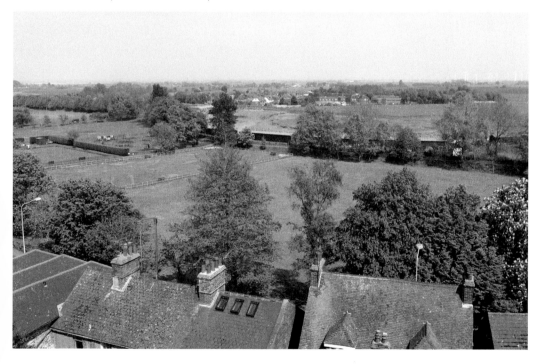

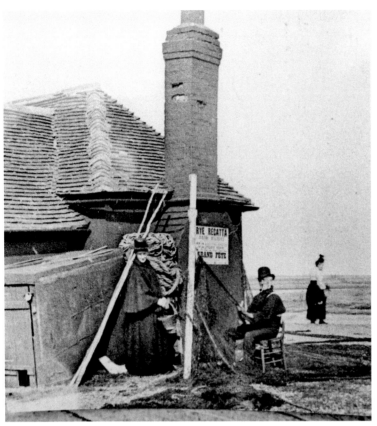

Ferry Cottage

This small cottage was in 1859 the ferry house, owned by Rye Corporation and occupied by the ferryman Thomas Cook. It was surrounded by saltings owned by the Harbour Commissioners and was only yards from tidal mud, with the river being on a different course from today. The ferryman and his wife are pictured with a woman at the river edge in the 1890s. The current owner, Margaret Houslander, found the paddles in the garden.

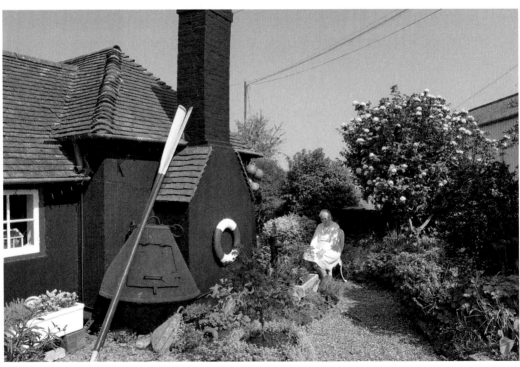

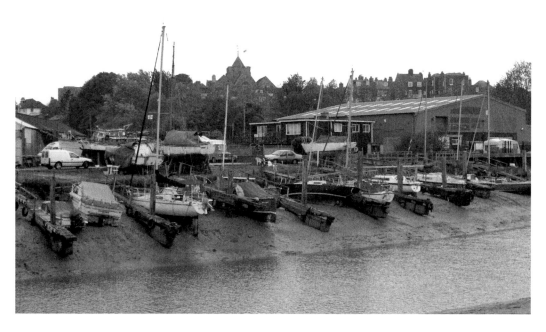

The Southern End of the Fish Market

This area is where the tidal River Rother is joined by Rock Channel, the combined rivers Brede and Tillingham, at the south-east of the town. The 1901 photograph shows two sailing smacks with nets furled. RX139 was the *Forget-Me-Not*, built in 1874 and owned from 1895 by John Mark Breeds. It finished fishing in 1902. The area is now a leisure boatyard.

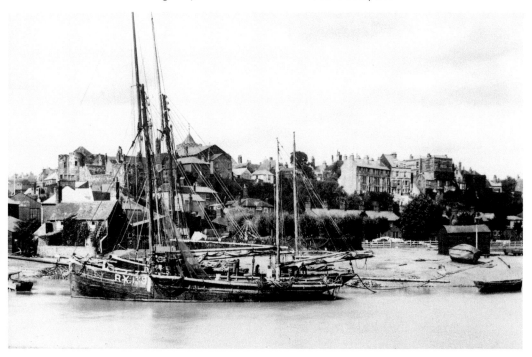

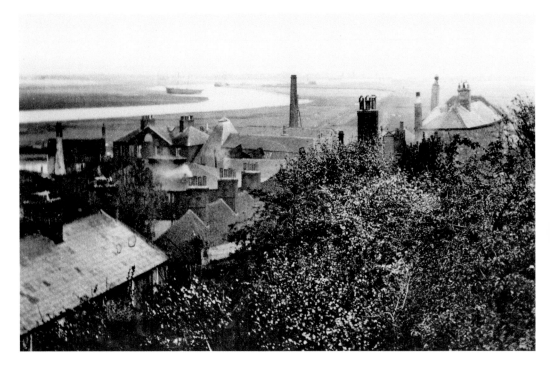

Rother Ironworks from Sea View Terrace
The area south of the town adjoining Rock Channel was the shipbuilding centre of Rye. Rother Ironworks started in 1863 and succeeded in general founding work after early efforts to build iron ships. It closed in the 1980s. The building on the slope dating from the 1830s is Ypres Castle Inn, now a popular live music venue. In the background, the Rother winds its way to Rye Harbour.

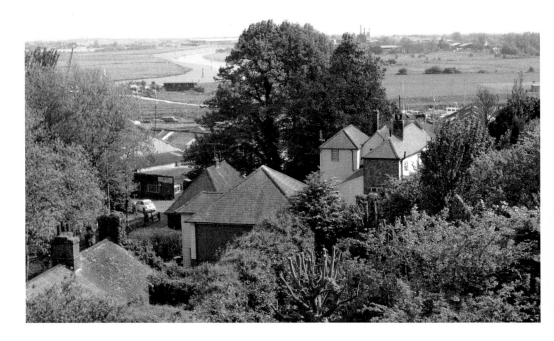

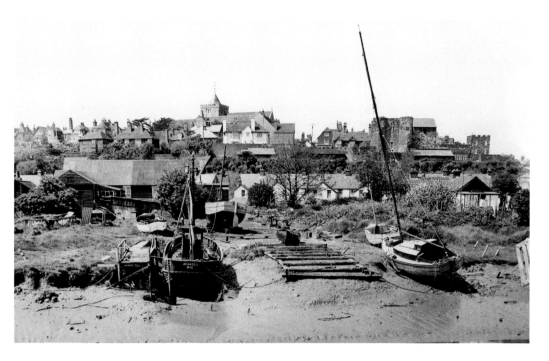

Phillips' Boatyard

John Phillips was listed as a boat builder from 1890 at this yard at the eastern end of Rock Channel. By 1909 he had been succeeded by Herbert Phillips and the yard has only recently changed hands from the family. The business was known for clinker-built fisher boats (i.e. made from overlapping wood planks). It now provides moorings and repairs and still has the metal-roofed engine shed seen in the 1960s photograph.

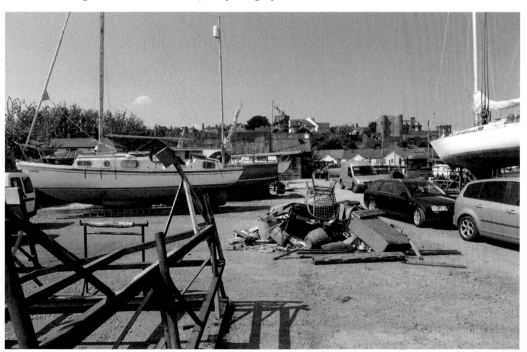

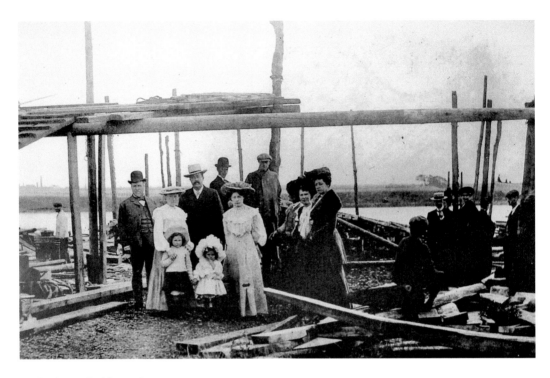

Rock Channel Shipyard

This yard was run successively in the nineteenth century by J. C. Hoad and G. & T. Smith. The Edwardian photograph shows a group of men, women and children in varied dress among the scaffolding and wood debris. The occasion is presumably the aftermath of a launch. The Holkar dynasty were the rulers of Indore in India. The yard was redeveloped as houses, flats, workshops and a piled quay in the 1980s.

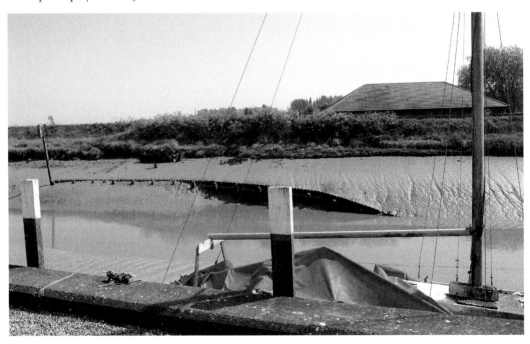

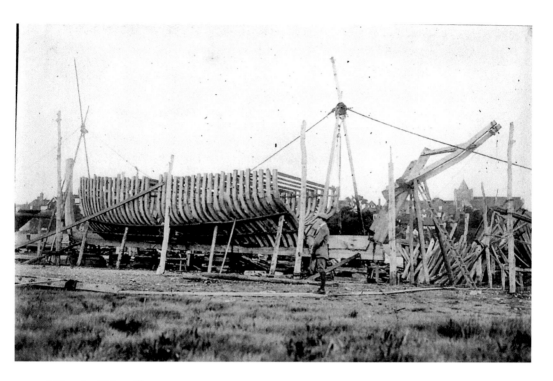

A Trawler Takes Shape

The frames for a deep-sea trawler are shown being assembled with a pulley, probably in the 1900s. The yard was a large employer, building mainly sailing-trawlers for the North Sea ports. The current photograph is correctly aligned in relation to the church tower, but is limited to one edge of the site by the redevelopment housing behind the camera.

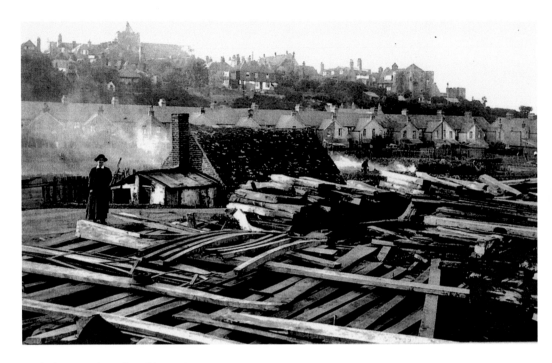

A Timber Stack at the Shipyard, 1922

The upper photograph shows timber stacked ready for use at G. & T. Smith's yard. A 1927 map shows that a sawmill stood to the left of this picture. The small building was occupied by Vidler & Sons, merchants in 1859. The allotments behind are all that remain from the land uses of the earlier view. They are currently disputed between the town council, the allotment authority, and the district council, to which they were transferred in 1974.

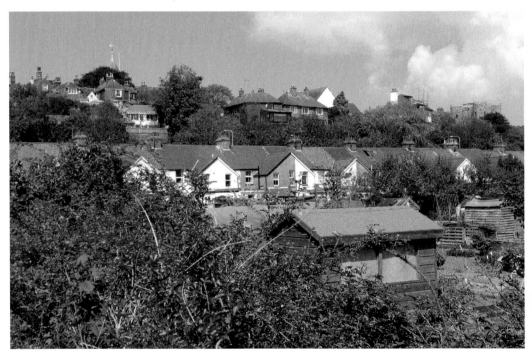

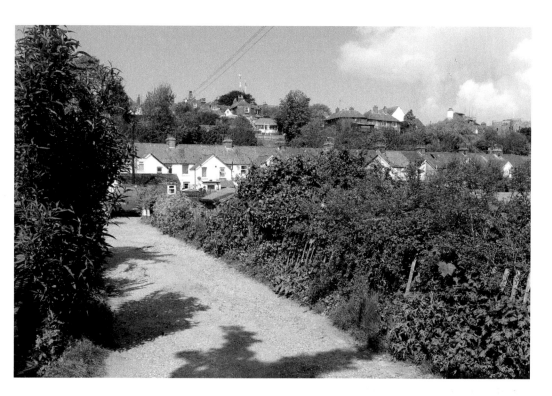

Shipyard Lane in the 1870s

This narrow unmade track is marked on the Rye tithe map of 1840. It gave access from the road around the foot of the cliffs to the shipyard. The pair of cottages was replaced by the second phase of the terraced housing in the modern photograph in the 1900s. The building second from right was a blacksmith's forge. Sadly, the two-storey polygonal summer house at the clifftop has not survived.

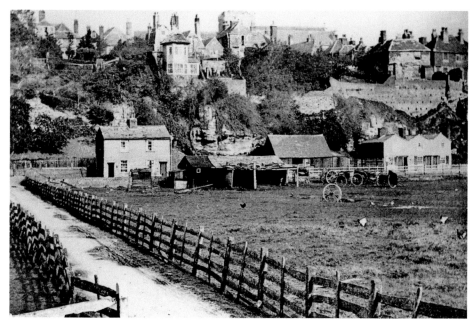

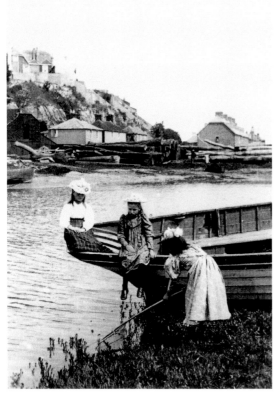

Hessell & Holmes Shipbuilding Yard at the Strand

The posed figures are typical of George Woods, the Hastings amateur photographer, and the photograph probably dates from *c.* 1890. Beyond the river are heavy timbers laid out in Hessell & Holmes's yard. In 1858, they were also described as shipowners, millwrights, iron founders and steam sawmill owners. The company built the first steamer in Rye and was credited with the most handsome vessel ever to be built in the town, the *Marian Zagury*, a fast clipper schooner 104 feet long and used for the fruit trade. Both were launched in the 1850s. The building on the left was the company's blacksmith's forge. The first phase of the South Undercliff terraced housing can be seen on the right. The modern photograph shows a former Penzance fishing boat now converted for leisure use.

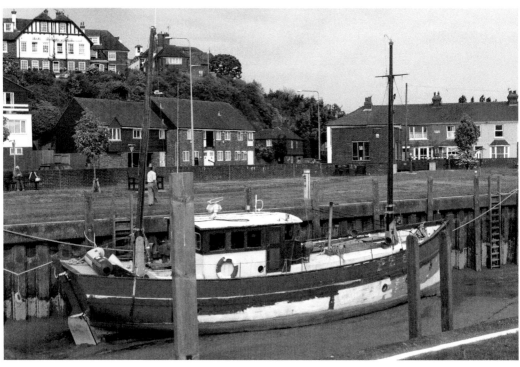

The Strand from Hoad Brothers Shipyard

This view from the turn of the century shows more of the west bank of the Tillingham and the site of another shipyard, which was owned – as well as several terraces of workers' housing beyond Winchelsea Road – by Hoad Brothers. Beyond the channel, the Hessell & Holmes forge from the previous page can just be seen beyond that company's sawmill building. Above, at the top of the cliff, is the Hope & Anchor Inn, scene of a 'good supper for the players' after a 'Grand Match of Cricket' between eleven shipwrights of Hoad Brothers and eleven of Hessell & Holmes. The winding gear and poles were used in the hauling and support of boats on the sloping bank. The quay today is piled both sides and owned by the Environment Agency as successor to the Harbour Commissioners. It is maintained as an open space, a venue for the Rye Farmers' Market and the annual Maritime Festival. It is also a popular meeting place for motorcyclists. The brick wall beyond the grass was raised in recent years to update the town's protection from tidal flooding.

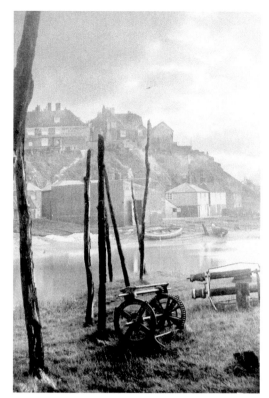

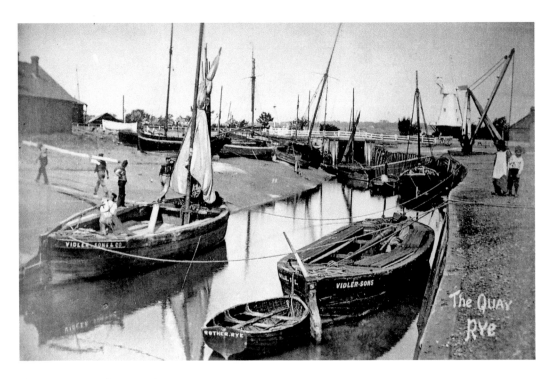

River Barges at the Strand Quay *c.* 1900
Vidler & Sons was listed in 1867 as Lloyd's agents, shipowners, timber (and general) merchants, and ship and commission agents. The river-sailing barges navigating the three rivers inland formed part of the business. Timber is seen being unloaded on the unpiled west bank of the channel.

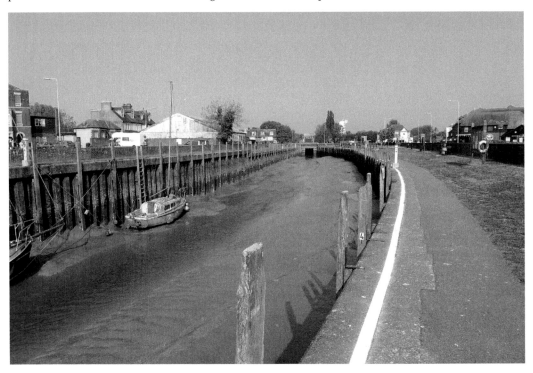

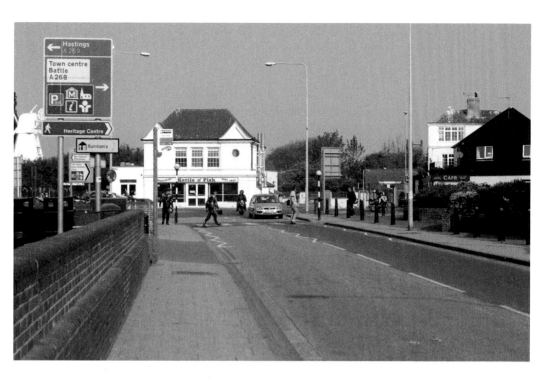

Motorcyclists at the Kettle O'Fish Roundabout
The prominent building at the mini-roundabout where the A259 trunk road is joined by the A268 into the town is now a fish restaurant and takeaway. In the 1950s flooded scene it was the showroom and boardroom of the former Rye Gas Company, whose works and gasholder can be seen beyond. The tall gate canopy of the Pipemakers Arms is on the right.

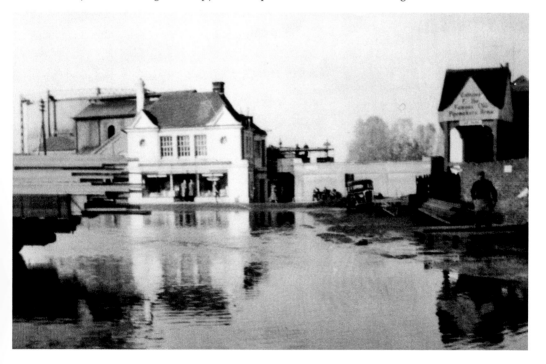

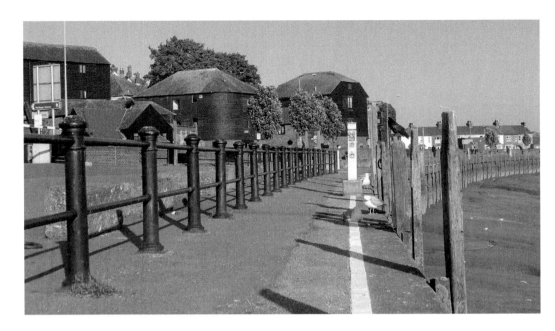

The Strand Quay and Warehouses

A conveyor is loading cargo from the lorry to the coaster. The brick and weatherboarded warehouses date from the early nineteenth century and served the coal and corn merchants based at the Strand. They were converted to shops, wine bars and flats in the 1980s. Both photographs show the flood wall built when the A259 road was rerouted along the quay in the 1960s.

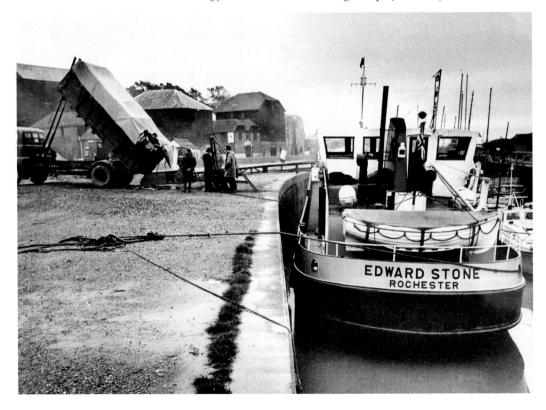

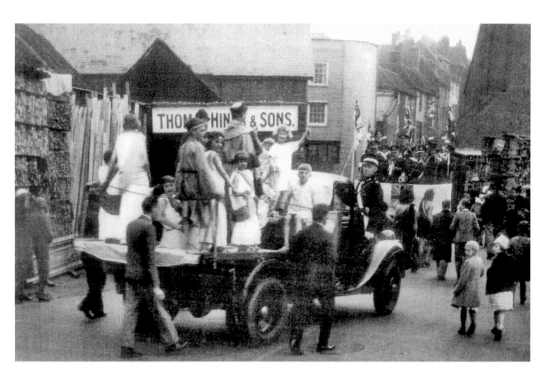

Rye Carnival outside Hinds' Yard

The 1960s photograph shows the warehouses and stock of Thomas Hinds & Sons Timber Merchants. The site was redeveloped as flats for retired people in the 1980s by McCarthy & Stone, who donated one of the warehouses, a listed building, to the town for conversion and extension to house the Rye Town Model & Heritage Centre.

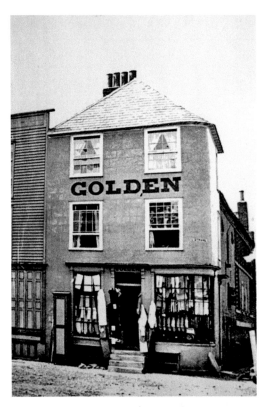

Historic Shopfronts at the Strand
These buildings have changed very
little since the early nineteenth century.
Edward James Heath was listed as a linen
draper and clothier at the Strand in 1839,
and William Golden followed him from
1858 to 1867. Both the stucco and the
weatherboarded buildings have unusual
curved corners and contemporary wood
shopfronts.

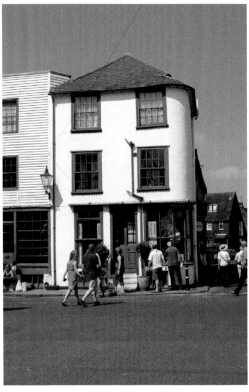

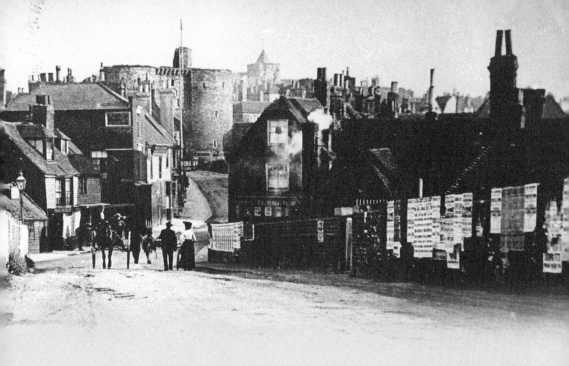

CHAPTER 7

Approaches to Rye

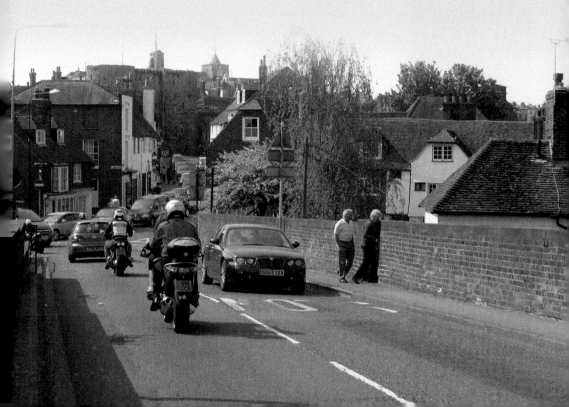

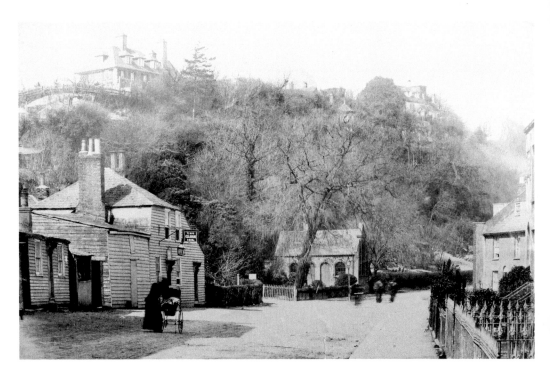

Northern Approaches

The previous page shows the main route into the town in 1910 through the Landgate, raised over the railway bridge since 1851 and diverted around a one-way system since the 1960s. Military Road, on this page, was a private track taken over and extended by the government during the Napoleonic Wars. Both the Globe Inn and the terraced housing date from after the Embankment Act of the 1830s.

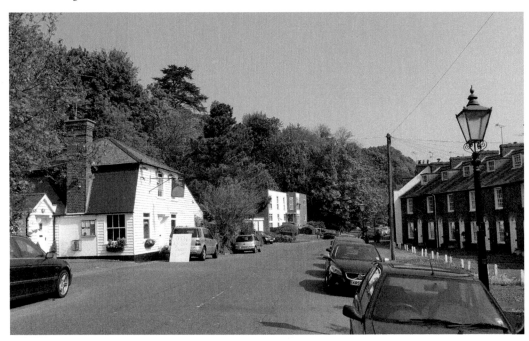

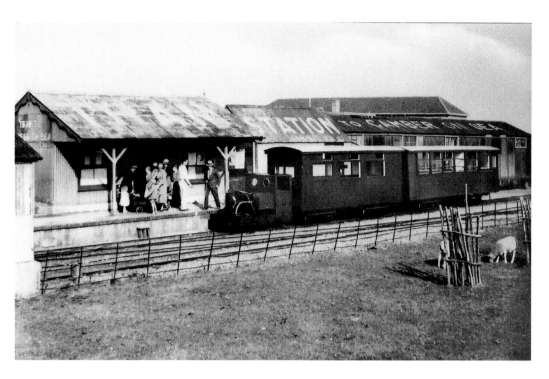

The Rye & Camber Tram

This light railway was established at the turn of the century to cater for golfers and others travelling along the east bank of the Rother. It became popular with tourists, as shown in the 1930s view of the Rye station at New Road. The newly built secondary modern school is behind. The Camber station survives as a studio, and is pictured here with golfers Anthony and Susan Tugman.

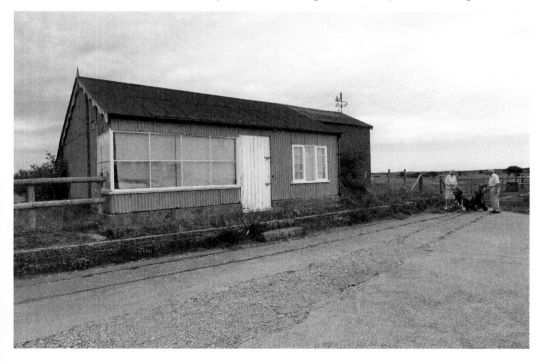

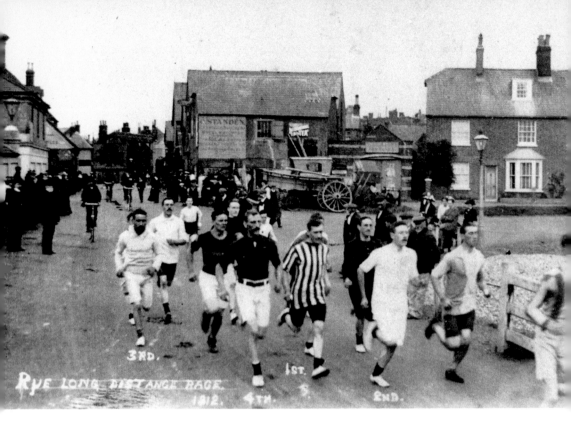

Inside image: RYE LONG DISTANCE RACE. 1912. 3RD. 4TH. 1ST. 2ND. STANDEN

Rye Long Distance Race at the Strand, 1900

Rye and Winchelsea were at one time linked by a bridge at Rock Channel and a track past Camber Castle. The military established a better road during the Napoleonic Wars, and runners were following that route. Charles Standen was listed as a wheelwright between 1909 and 1922. The gas works manager's house is on the left.

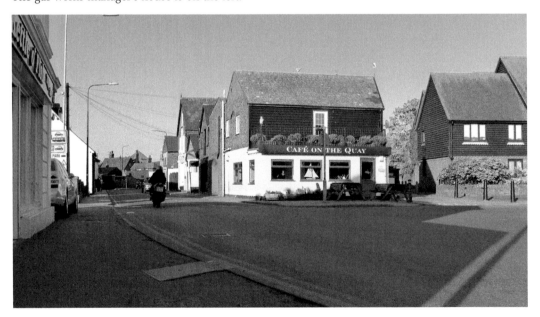

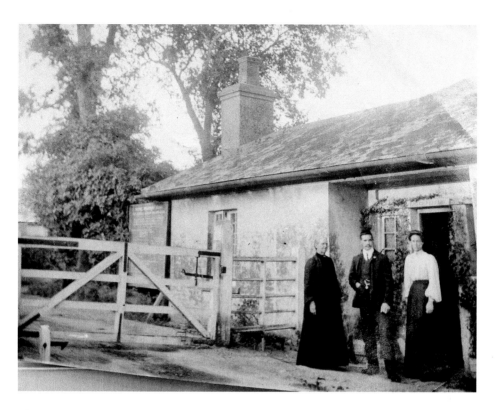

The Winchelsea Road Tollgate

Most tollgates on turnpike roads were removed when county councils were established as highway authorities in 1888. This gate and cottage survived until 1926, when the county took over from the military. The current view shows a group taking part in the annual Rye Rotary Club Walk on 15 May 2011.

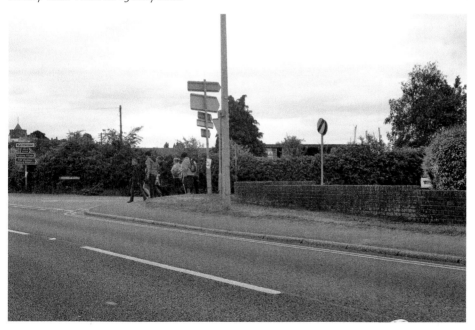

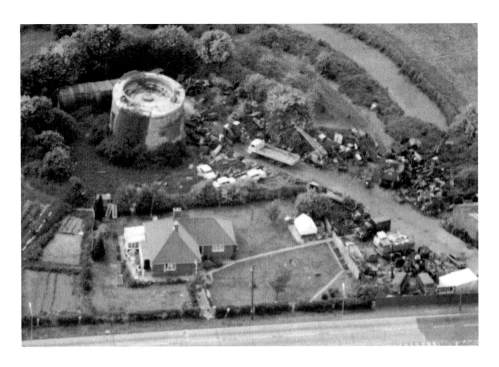

The Martello Tower in New Winchelsea Road

A chain of these towers formed part of the coastal defences during the Napoleonic Wars. Another survives at Rye Harbour, and one was destroyed by erosion at Winchelsea Beach. They were of brick construction and had a traversing cannon on the flat roof. They are difficult to convert and both local examples are currently disused. At the time of the 1960s photograph, the tower was surrounded by Harry Hooker's scrap-metal yard.

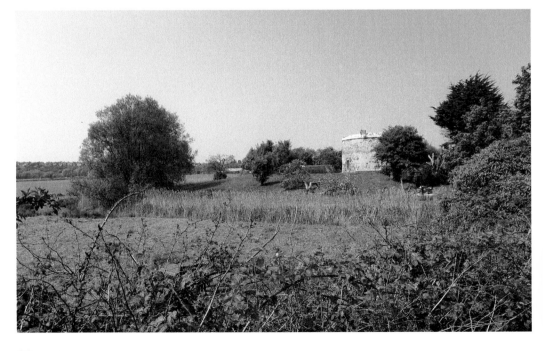

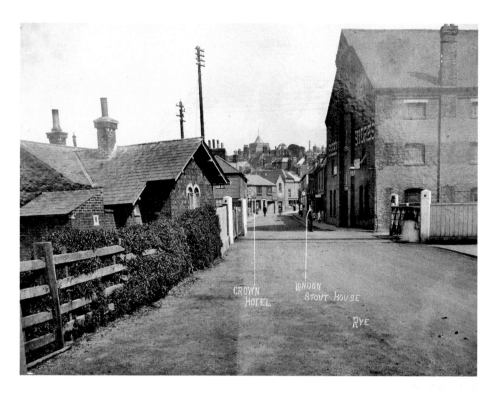

CROWN
HOTEL

LONDON
STOUT HOUSE

RYE

Ferry Road

The second land approach to the medieval town was from the Udimore and Brede ridge to the west, continuing via a ferry to the Strand. Here Thorp's corn warehouse is seen beyond the railway level crossing and keeper's cottage. The captions refer to the review of public houses in the 1900s. The pedestrians are Brenda and Adam Smith; the latter was shortly afterwards elected to Rye Town Council.

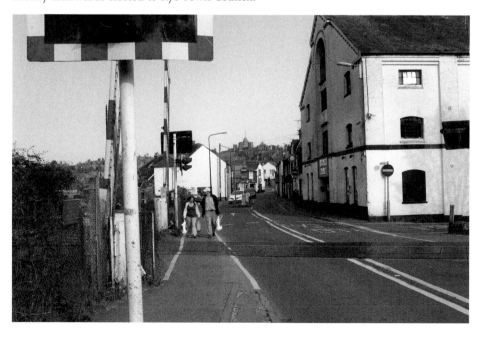

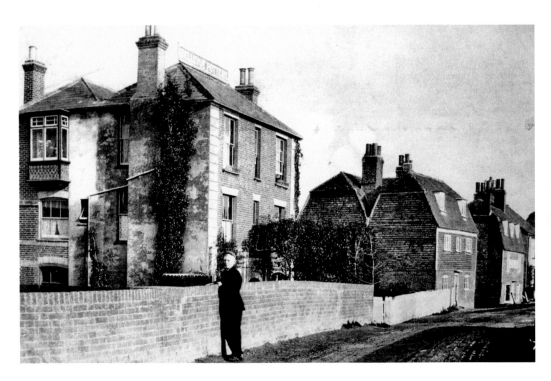

The Udimore Road Bridge

The ferry was rerouted from the Strand to Ferry Road in the late medieval period and replaced by a bridge over the River Tillingham in the eighteenth century. Nearly every building in the earlier photograph has been replaced, but the overall visual affect is the same. Bellevue Pottery, on the left, built in 1868, was replaced recently by flats and houses. The Ferry Inn was on the right in the Victorian period.

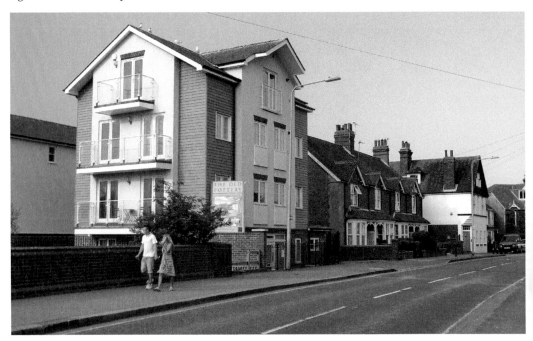

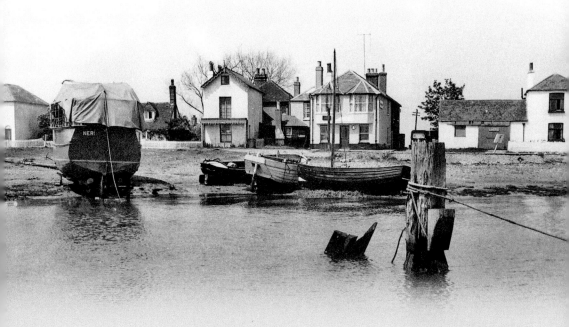

CHAPTER 8

Surrounding Areas

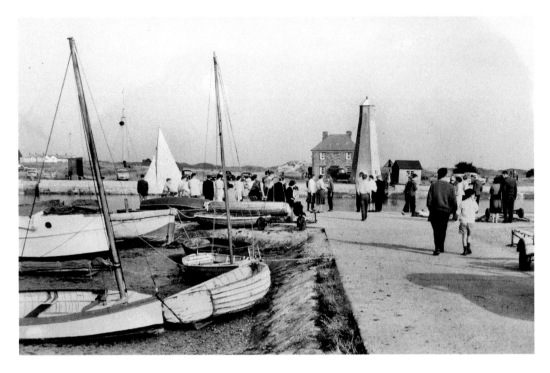

Rye Harbour

What became Rye Harbour was at the end of the eighteenth century cottages, the Ship Inn and a custom house beside the shore. The previous page shows this area in the 1960s, before the flood bank was built. Both old images are from the Frith Collection. The views on this page look east to the river and the harbourmaster's office, which replaced the lighthouse in the 1960s. The lifeboat was *en route* to assisting a kite surfer.

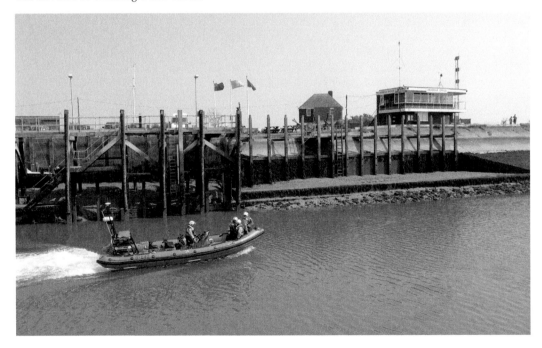

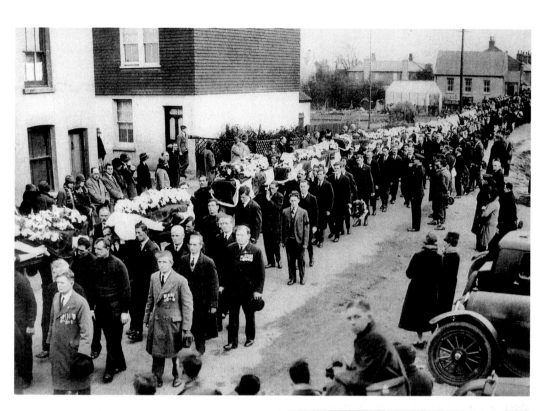

The Rye Harbour Lifeboat Disaster
Rye Harbour was devastated by the loss of all seventeen of its lifeboat crew in a storm on 15 November 1928. The crew were going to the aid of a Latvian steamer, whose crew had already been rescued by another ship. Here the funeral procession is passing towards the church. Below is the monument in the churchyard, which bears the inscription, 'We have done that which it was our duty to do.' The annual commemoration service is a major event in the life of the village.

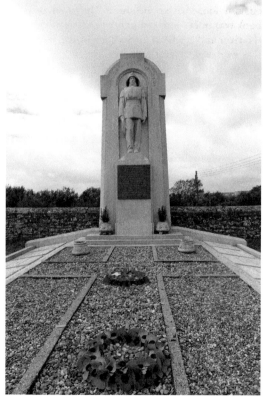

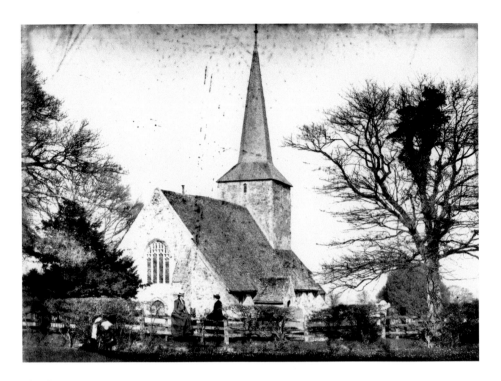

Playden

This parish at the top of Rye Hill has its origins in the Bronze Age and was the site of a Saxon church mentioned in the Domesday Book. The present church was built *c.* 1190. The tall timber spire was added in the fifteenth century. This was a landmark for mariners from both Playden and Rye. The upper photograph dates from the 1900s. The lower was taken at the annual church fair on 9 July 2011.

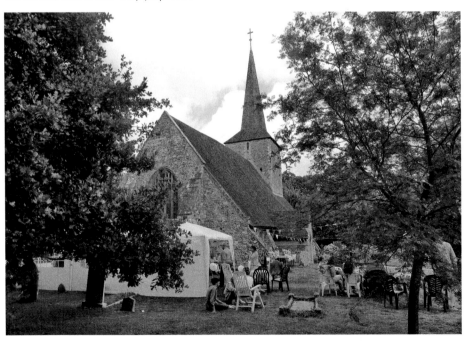

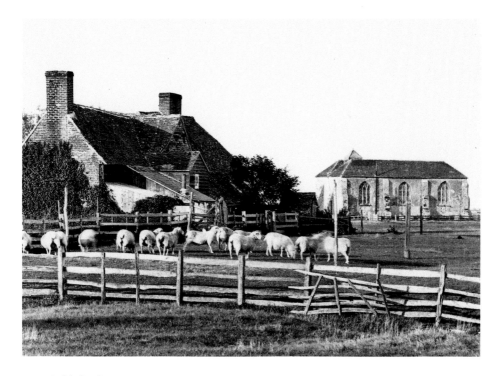

East Guldeford

This tiny place on the A259 east of Rye did not exist until 1478, when courtier Sir Richard Guldeford enclosed 1300 acres of marshland, mainly in Playden parish. The brick church was built in 1505. The 1890s photograph is by George Woods and shows the former vicarage. Then, as now, sheep pasture was the main land use. The church is now hidden by the pyramid-shaped modern building.

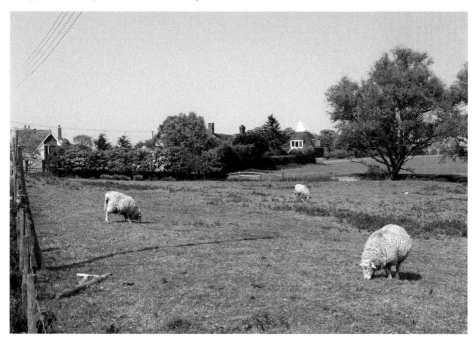

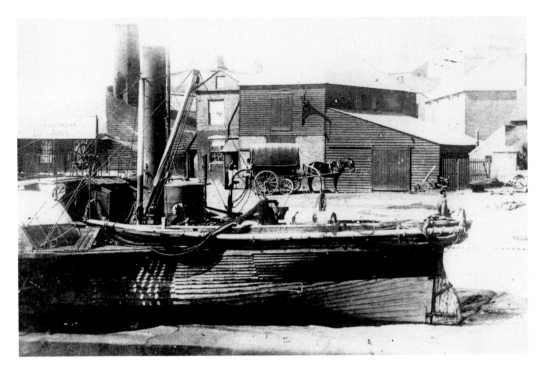

A Difficult View to Match
This detail from a larger photograph shows Rother Ironworks and a steam paddle trawler on the bank of the Rother in c. 1890. It proved too difficult to match with a meaningful modern view following changes to the river, demolitions and new industrial and housing development.

Acknowledgements

Special thanks are due to my collaborators Heidi Foster and my son Oliver Dickinson. Heidi has been heavily involved in the initial selection and scanning of the old images and both have taken part in the final selections and layout for the book. Heidi's good judgment and organisational skills and Oliver's enthusiasm and visual ability have been much appreciated.

With the exception of Oliver Dickinson's photograph on page 14, all 2011 photographs are by the author. Thanks are due for permissions to reproduce the 'old' images on the following pages: 6 (Austrian National Library, Vienna), 71, 91 and 92 (© The Francis Frith Collection).

Typing and IT support have been provided by Brigitte Bass and June Dunnett.

I am grateful to Frank Palmer, Bob Rogers and Rye Castle Museum for unlimited access to their photographic collections, to Jane Fraser Hay for unstinting help, and to Peter Ewart and Steve Peak for information and advice.

I have drawn heavily on David and Barbara Martin's extensive work on Rye's buildings in *Rye Rebuilt: Regeneration and Decline within a Sussex Port Town, 1350–1660* (2009).